CRAM DOWN

Renegotiating Mortgages, Car Loans, Student Loans, Credit Card Debt and Other Obligations in the Age of Wall Street Bailouts

SILVER LAKE PUBLISHING

ABERDEEN, WA • LOS ANGELES, CA

Cramdown

Renegotiating Mortgages, Car Loans, Student Loans, Credit Card Debt, Taxes and Other Obligations in the Age of Wall Street Bailouts

First edition, 2009
Copyright © 2009 by Silver Lake Publishing

Silver Lake Publishing
101 West Tenth Street
Aberdeen, WA 98520
•
P.O. Box 29460
Los Angeles, CA 90029

For a list of other publications or for more information from Silver Lake Publishing, please call **1.360.532.5758**. You can find our Web site at **www.silverlakepub.com**.

The Silver Lake Editors
Cramdown
Pages: 248

ISBN: 978-1-56343-904-9

ACKNOWLEDGMENTS

The Silver Lake Editors who have contributed to this book are Sander Alvarez, Esq., Sue Elliott, Kristin Loberg and James Walsh. We also wish to thank Cornelius McCarthy and Michael Z. Stahl for their contributions.

This is the 19th title in Silver Lake Publishing's series of books dealing with risk and economic issues that face people living in the United States and other developed countries.

This book is intended to make debt instruments and other financial agreements understandable to non-professional readers. The Silver Lake Editors welcome feedback. Please call us at 1.360.532.5758 during regular business hours, Pacific time. Or e-mail us at **publisher@silverlakepub.com**.

James Walsh, Publisher

TABLE OF CONTENTS

CONTENTS

CHAPTER 1

TACTICS AND STRATEGIES FOR (RE)NEGOTIATIONS

In December 2008, American International Group CEO Edward Liddy confirmed to *The Wall Street Journal* that his company intended to renegotiate for even better terms on the bailout monies it had received from the U.S. Treasury. He said:

> *As soon as we make good progress on selling assets and paying down that debt, we intend to go down to Washington, D.C., and negotiate with the new Treasury secretary.*

The federal government had rescued AIG three months earlier, when the insurance giant faced bankruptcy, by loaning it some $85 billion at high interest rates. In mid-November 2008, the Feds had agreed to a revised package worth about $150 billion—of which about $60 billion was a loan—that **reduced AIG's interest rate** by about a fifth.

Liddy, who had joined AIG as part of the government rescue, **wanted even more**. He hoped to cut a 10 percent dividend on preferred shares AIG had given the federal government and to have the government reduce its 80 percent holding in AIG—in order to encourage private investors to provide capi-

tal to the firm. Liddy had made no pretenses about his plans; in at least one conference call with investment analysts, he had stated plainly his desire to seek a better deal as soon as possible.

Pundits complained bitterly about this news. They pointed out that AIG had been saved from bankruptcy not because the government thought it deserved a lifeline but to prevent a greater shock to the financial system if it failed.

> You shouldn't be angry about Liddy's shameless bid to change the terms of deals his company had made. You should learn from it. Finance—even personal finance—isn't about shame or other moral matters. It's about practical matters of money. Who has it...and who needs it.

The title of this book is *Cramdown*—and it's a word that has been getting a lot of use in the last few years. Strictly speaking, *cramdown* refers to the process of having a plan for reorganization confirmed over the objections of creditors in a bankruptcy proceeding. But the word has come to mean more than merely that in the age of Wall Street bailouts, rampant bankruptcies and booming loan modifications.

We live in the era of the renegotiated contract. You can complain about this fact—and, from a philosophical or moral perspective, there *is* a lot to complain about in that—or you can adapt and take advantage of the new rules of the financial game.

Negotiating—and *re*negotiating—is a skill, learned over years of dueling with stubborn opponents. In this book, and this chapter, we will share some of the lessons that experienced negotiators have shared with us. Since renegotiations are a fact of modern financial life, we hope this book will add some efficiency and balance to the process.

The marketplace for advice on renegotiating contracts and loans is dominated by "financial counsellors." In many cases, these are well-meaning people (often from the nonprofit sector) who bring a basically passive approach to negotiation. Most of the seasoned financial professionals we have interviewed doubt that nonprofit counselors are good at driving effective bargains. So, at times in this book, we advocate some more-aggressive tactics.

> **Before you take any action based on information or examples that appear in this book, speak with a legal or financial advisor who is familiar with your circumstances and your local legal jurisdictions. Every person's situation is unique...and yours may require special attention.**

That said, you don't need to be afraid or feel nervous when renegotiating with a creditor. If nothing else, you're going to be saving yourself money in the process. That should give you the courage and motivation to act decisively.

You are your own best advocate. No one has your best interest at heart more than *you*.

Successfully renegotiating a loan or contract with a creditor (or collector) requires a well-thought-out plan. And many phone calls. And, usually, a few rejected settlement proposals. Don't worry about this; remember that it's a process.

QUICK RUNDOWN OF BASICS

Generally, **unsecured debts are easier** to renegotiate and **secured debts are harder**. But you can renegotiate either—you'll just have work a lot harder and be a lot smarter about the secured ones.

Unsecured debts include:

- medical bills,
- credit cards,
- department store cards,
- personal loans,
- some student loans, and
- bounced checks.

Secured debts include:

- mortgages and home loans,
- auto loans and leases.

With unsecured debts, there is nothing "attached" to the loan promised as repayment. Unsecured loans are typically given to people with good credit, due solely to the fact that they have good credit. These are the type of debts that a creditor is willing to settle, as it has no way to guarantee it will receive anything from the borrower.

Most of time, renegotiating these debts will start (and occasionally *finish*) with you talking to a representative of your creditor on the phone. Here are some tips for talking with creditors:

- **Names and details are critical.** Every time you speak with a representative, confirm that person's first and last names—or partial name and location or employee number, if the company doesn't allow full names. Always ask for the person's direct contact number, in case you are disconnected or need to call back. On your end, always note the date and time you spoke.

- **Be clear.** Explain to each person you speak with that you have an account that you are having or soon will have trouble keeping current. You need to modify there terms of the agreement or there is a serious chance that you'll fall further behind or go into default.

- Be "friendly but firm" with people you contact. **Frontline contact people are usually information-gatherers, not decision-makers.** And they deal with lots of angry, incoherent people—so try not to be one of those. Tell each contact that you're keeping a record of your conversations and want to be sure you document the conversation accurately.

- Don't make threats or demands. And don't say for a fact that you're headed to default (if you're not there already). Some creditors don't like renegotiating

accounts that are "lost causes." You need to emphasize that your account needs attention—but that it can **still be a performing asset** with a few adjustments.

- If they are willing to renegotiate, most creditors will start by asking you questions about your financial situation. **This is not the time to "sell" them or be unrealistically upbeat** about your prospects. You need to establish that you are in a *bad* financial place.

- Avoiding uncooperative people can make a big difference in settling or not settling. If the person with whom you're speaking isn't helpful, **ask to be transferred** to someone else. And start over.

- **Be patient**—and don't be discouraged by the word *no*. The decision-maker may be several levels above even a supervisor you'll speak with on the phone (at least initially). If you get resistance, keep "escalating" your call to the next person higher on the organization chart.

- **Take the initiative** in the first call and follow-ups. Don't wait for the creditor's reps to contact or get back to you. End every contact with a statement of when you'll contact again. And **do that**.

DOCUMENTATION IS KEY

Create a spreadsheet that acts as a **call log** to help track your communication with the lender. It will

also keep your notes in one place. This is important because **you will usually end up talking to many different people**. Companies have phone notes; it's important that you also track conversations so that, if you run in to a roadblock or dead-end, you can keep pushing forward. You can reference promises, comments or details that may help you overcome objections as you talk to people.

On the spreadsheet, you should note:

- the date and time of each call or contact;

- the number you called or address you used;

- the person with whom you spoke (be sure to get the full name of each person—or partial name and location or employee ID number, if company policy doesn't allow full names);

- notes of the conversation, including anything the person said about the status of your account and what you might do to improve it;

- any references the person made to previous calls or contacts from you;

- any promises or commitments you or the contact person made to provide information, send documents or take other actions;

- the last thing each person said.

Not only does this keep you organized, it helps document your efforts to improve your situation

should the creditor initiate collection (or legal) proceedings. You'll have it available to all parties to show you've made a good faith effort to work out an amicable resolution to the problem.

Creditors will try *not* to change agreement terms if those changes conflict with their profit models. So, you need to show them that, with the adjustments you seek, you will make payments reliably. Reliable payments are very important to creditors.

> A debt modification needs to be a mutually-beneficial transaction. You will likely have to compromise on some points to get a deal you and your creditor(s) can accept. Your main goal should be to adjust the terms of your debt so that you can meet them until the debt is paid. If you can't achieve this, there's little value for you in the renegotiation.

With those last few points in mind, here are some addition tips for renegotiating debt agreements with creditors:

- Answer direct questions truthfully, but don't volunteer conclusions about how much you can pay. If you offer the highest amount you can manage, this is going to be the starting point from which the creditor will try to work *up*.

- Never accept the first offer you receive without trying to get a better deal than than the one that's been presented.

- You'll need to know what constitutes a good settlement offer and how different creditors operate. A 50 percent settlement might be the best you'll ever see with one creditor, while others that might settle for 30 to 35 percent of the outstanding balance.

- Be wary of creditors who tell you to consider Consumer Credit Counseling or bankruptcy. This is a sign that the creditor (or, more often, collection agency) is trying to scare you into paying quickly.

> CCC plans sometimes include monthly payments equal to or higher than what you are currently paying. And bankruptcy creates a legal record that last a decade. Neither option will be good for you.

- Sometimes doing nothing (temporarily) is the best negotiating strategy. Other times doing nothing will backfire—and you'll miss a good settlement opportunity.

- Creditors and collection agencies are not going to write off hundreds or thousands of dollars without a fight. So you better have a thick skin and be willing to persevere...sometimes for several months.

Don't be naive about debt renegotiation. Some people feel that, since they have been a longtime

customer the company will be sympathetic to their hardship and give them a break. Don't make this assumption. A creditor **looks at you impersonally**; it's generally more concerned about the overall performance of large pieces if its debt portfolio. You are a small piece of those larger equations.

Don't take this lack of personal response as an insult. In fact, it can be liberating. You don't need to feel awkward or insecure about renegotiating your account. The account is little more than a number to the creditor. And the renegotiation is just business.

Your best negotiating tool is knowledge. Before you speak with a decision-maker, research that creditor. Look for Internet user groups of present or former customers. Try to get some sense of how the company operates. A tactic that helps close a renegotiation with one company may have the reverse effect with another.

LAWSUITS: TRUTH & BLUFFING

Creditors routinely threaten litigation. Most of the time they're bluffing. But not always. So how do you know whether the threat of a lawsuit is real or just a bluff? You need to know the profile of a particular creditor or collection agency to determine if the threat of a lawsuit is legitimate.

One of the main reasons creditors and collection agencies use law firms to collect debts is that law firms are good at bluffing. The official appearance

of a law firm's letterhead helps—this, by itself, is sometimes enough to get people to pay.

> **What if one of your accounts is referred to a law firm? Does that mean for sure you're getting sued? Not necessarily. If the law firm is not registered to practice law in your state, it can't represent a client in court there (and would have hire a local firm). So, the odds of that firm suing you diminish.**

Even if they are not inclined to sue you, collection law firms can be very aggressive with their tactics. Often, "The Law Offices John Doe" will consist of one attorney, Mr. Doe, and several dozen very aggressive collections pros. These are often **the most insulting, loudest debt collectors** you'll ever deal with. They use their association with a "law firm" to intimidate and harass debtors.

Your approach, on the other hand, doesn't have to change. Ignore the threats and tough talk—don't take them any more personally than you take the slights from other creditors. Even if this collector yells insults at you, you're really just a number in a portfolio to him. Let his demands that you pay something immediately pass. Focus on stating clearly **what _you_ need** in order to have a realistic chance of settling the debt.

Faced with aggressive collectors, **some people try bluffing** themselves—usually about declaring bankruptcy unless the collectors stop calling. This can be a risky gambit. Some creditors make a policy of

not negotiating with anyone who uses the threat of bankruptcy as a tool.

Logic might suggest that the creditor would rather get some money rather than (potentially) nothing in a bankruptcy. But remember that most creditors are dealing with populations of delinquent accounts. One West Coast collections attorney told us:

> *It's just a policy we have. Like how the government won't negotiate with terrorists. We won't negotiate with people who are threatening to file {bankruptcy}. If we did it once, then everyone would be pulling the same trick.*

And he mentioned another reason: some collection law firms often don't have much discretion about accepting settlement offers. They have to run offers by their clients; if the debtor is threatening bankruptcy, the creditor may ask the attorney to assess the chances of that—which is more work. So, it's easier to have a "no deals" policy.

A caveat: Despite what this attorney said, some collections law firms actually buy delinquent accounts from the original creditors for pennies on the dollar and then try to collect more. In these cases, the law firms will be inclined to make deals.

THE HIERARCHY OF SETTLEMENTS

If you keep a patient, clear perspective and diligently follow up, you will—usually—end up talk-

ing with (or corresponding with) a decision-maker at some point. By this point, you will probably have stated your situation and your desired settlement or adjustments enough times that you can make your case clearly. **Do that again.**

And then be ready to respond to a settlement the decision-maker may suggest. We've already noted that you usually shouldn't accept the first offer a creditor makes. But how do you know if a later offer is a good one?

The first question you need to ask yourself is: **Can you afford the settlement?** You should be confident that you can keep up your payments in whatever revised agreement you make.

The next question you need to ask is: Where does this deal fit on the hierarchy of settlements? The *best* settlement is one that allows you to keep the account open. However, a settlement usually means the account is closed—and **all closed credit accounts will hurt your credit rating**. But some types of settlement do more damage than others. Here's a quick rundown of how different settlements appear on standard consumer credit reports:

- The best way (for you) to have a settled credit account reported to credit bureaus is "**paid in full**, closed by customer." Most creditors will only report the account this way if you do, in fact, pay the balance in full. But, if you're paying most of the balance, you may be able to convince the creditor to report the account closed in this way.

- A little worse is the report "paid as agreed, closed by creditor." This makes it clear that you settled the account for less than the full amount owed. How much less usually won't be reported. (And, sometimes, you can convince the creditor to report "paid as agreed, closed by customer"—which is a little better.)

- Next comes the report note "settled in collection" which can mean that you settled the account with the creditor itself or a collection agency. The significant point here is that the account was reported as sent to collection, which is bad for your credit rating.

- "Settled/third-party arrangement" (though this wording changes with each credit bureau) means that you settled the account with the assistance of a Consumer Credit Counseling Service—a nonprofit organization usually funded by creditors. You make one monthly payment to the Service, which disburses your funds to pay each of your creditors for you.

A consumer credit counseling agency will usually be able to get your interest rate lowered and stop the harassing collection calls. But you have to pay the full balances on your various accounts—with interest. In other words, your creditors will not be forgiving any of the balances. Yet credit bureaus rate this option rather harshly, like a partial settlement.

- A "Settled charge-off" is less negative than an "open charge-off" or a foreclosure or bankruptcy on your credit report. This note means that, after the creditor had deemed your account uncollectible, you worked out some agreed-upon settlement.

- Foreclosure or bankruptcy. Usually, these are last-resort options (and we'll consider the mechanics of each in later chapters of this book). Both can stay on your credit report for up to 10 years.

The important thing to keep in mind about these reporting options is that they are negotiable. Just as you negotiate how much you can pay on an account, you can negotiate how the creditor will report your account status to credit bureaus.

It's not usually possible to have a charge-off reported as "paid in full"—but smaller adjustments are feasible. Convincing a creditor to report your account "Paid as agreed" instead of "Paid in collection" can make a big difference to your credit rating.

THE IMPORTANCE OF LIQUIDITY

An important thing to keep in mind when it comes to renegotiating debt is that liquidity is important. You need to have some cash available, because most modifications and adjustments will require some fees to be paid or payments made on account. And no one is as liquid as they would like to be. Or as

other people think. For instance, Bill Gates has never been as rich as he seems; if he ever needed to liquidate his holdings, the value of Microsoft stock would plummet while he sold.

Liquidity buys you time. This is especially important (for you and everyone else) if you're negotiating to keep a house in the midst of a falling housing market. If you can stretch things out, you can stay in your house. And the larger real estate market can realize its lower prices more slowly—avoiding a "crash" and perhaps even starting to recover.

So, how do you manage some liquidity when you're already having problems making your basic debt payments?

The simplest way is to renegotiate your biggest debts so that their monthly service costs you less— thus, freeing up your earnings or cash flow to give you liquidity for managing smaller accounts.

There are other, less simple ways:

- Get a debt-consolidation loan. It's generally not wise (or even possible) to negotiate for new debt when you're having trouble managing existing debt. But some people do manage this; and, if they time their loans well, they can "stretch out" their money problems. If you consider this course, remember that you're going to have to pay the money

back to someone, sometime. **You can't borrow your way out of debt.**

- Pay nothing and do nothing. How can this work? If you were unemployed and had no assets a creditor could pursue, you would be "judgment proof" and creditors would (at least temporarily) hesitate to take any action against you. But this doesn't make as much sense if you have some income or a house with positive equity.

> Between late 2007 and early 2009, many American homeowners were trapped in houses they couldn't afford—and that had negative equity because of falling sale prices. This was a rare example when doing nothing was a good strategy. Sadly, many people in those circumstances overreacted and voluntarily surrendered their houses to their lenders.

The 2007-2009 recession turned a lot of conventional financial wisdom on its head. The lack of liquidity in the U.S. economy and falling asset values had an *Alice in Wonderland* effect on standard financial and negotiating strategies.

Among the normally-bad ideas that worked in that period:

- paying late or being in default actually increased your chances of getting a lender to agree to renegotiation. In other words, "robbing Peter to pay

Paul" (accumulating cash instead pay-
ing the mortgage on time) worked for
some homeowners;

- loan modifications—normally, rare and
 hard-to-get things—became somewhat
 commonplace. Encouraged by govern-
 ment policies and edicts, lenders built
 entire departments dedicated to rene-
 gotiating loan terms.

We'll consider the detailed mechanics of managing
and renegotiating home loans in Chapter 2: Loan
Modification.

HANDLING COLLECTION AGENCIES

If a debt is with a collection agency, the original
creditor (OC) is not going to deal with you. In most
cases, the OC has written off the debt. You are now
dealing with the collection agency—in some cases,
the agency may actually *own* the debt.

The collection agency could sue you in court and
win a judgment, allowing it to garnish your wages
or hire a sheriff to take your property. But the
chances of this happening are small, unless the debt
is in the tens of thousands of dollars of value.

**Lawsuits and legal collection actions are too costly
and time-consuming to make sense for small or mid-
size financial disputes.**

The best way to deal with a collection agency is the **debt validation method**. This should be your first step in the settlement process.

Before you attempt to settle a debt, check the statute of limitations. Collectors only have a certain amount of time to sue you for payments. If the debt is older than the statute of limitations, you can tell collectors they are wasting their time by harassing you for an **uncollectible debt**.

In most situations, if a debt has gone unpaid and uncollected for between four and seven years, it's not longer legally enforceable. It can't remain on your credit report; and you can challenge any listing of it that does appear.

But most debt collectors are keenly aware of statutes of limitation and won't let them lapse.

What exactly are debt collectors? Under U.S. federal law, the group includes:

- companies that purchase debt (also known as junk debt buyers or JDBs),

- companies assigned to collect the debt,

- lawyers who send you letters to collect a debt.

The debtor has some natural advantages over the collector. Chief among these are **distance and time**. But, as we've noted before, collectors can get quite aggressive about scaring, shaming or tricking you into sending money.

For this reason, it's often a good idea to correspond with collectors in writing. (That also creates a paper trail of all your exchanges.)

In your communications, always keep the attitude that the collection agency will accept less money than it indicates to settle the account. It usually will. But how much less? Most companies pay pennies on the dollar when they buy the debts they're trying to collect. The specific amounts paid depend on many factors. Some examples:

- debts that have recently been charged off (usually six to 12 months past due): five to nine cents on the dollar of contract or invoice amount;

- accounts that are older and on which other agencies have tried to collect: 1.5 to two cents on the dollar;

- years-old, out-of-statute debts: one penny or less on the dollar.

With these numbers in mind, you usually do well to start a renegotiation by offering 15 to 25 percent of the amount in question.

Other practical points to remember when negotiating with collection agencies:

- It's best not talk to a collection agency on the phone. If you want to get vital information from the collection agency, or even "feel them out" for what they

would take as a settlement, go ahead.
Just keep your finger on the hang-up
button on your phone in case they start
getting nasty.

- Get your terms in writing before you
open your checkbook. Never expect a
creditor to meet an agreement that was
made verbally. Everything must be in
writing and, even then, you will prob-
ably have to fight to make the creditor
live up to his end of the bargain.

- Send all correspondence via registered
mail, receipt requested (about $3-$4 a
letter). And keep a copy of every letter
you send.

- Ignore "penalties and interest"—which
are typically fictitious amounts of
money added on by collectors to pad
their profits. These fees can add up to a
third or half of some collection account
totals.

Most collectors will be thrilled to get you to pay
the original debt even without the extra penalties
they add on and will usually be more than agree-
able in waiving these fees.

Some other, more strategic, points to keep in mind
when you're dealing with debt collectors:

- Time is on your side. As time passes, a
creditor will likely stop calling. The
longer the debt remains uncollected,
the better your chances of making a
good settlement.

- Never look too eager to settle. Take time to reach an agreement. Never let it slip that you need to settle the debt because you're buying a home, car or anything else like that.

- Don't accept the first, or even second, settlement offer. Make sure that the collector is the one calling you to push the deal forward. You won't reach an affordable settlement if the creditor thinks he has the upper hand.

- If you're contacted by more than one collection agency for the same debt, it means that the original creditor has hired a secondary collection agency. This suggests that the first collection agency has given up. The second collection agency has paid even less for the debt; it may be willing to take less.

- Negotiate your credit rating with the creditor. This is very important as a "paid" collection is as negative to your credit rating as an "unpaid collection." What you want is to have the note read something other than "collection."

- Don't play lawyer. It's a bad idea to use formula "cease-and-desist" letters (available at many Web sites). If you'd like to increase the odds of getting sued by a creditor or collector, send a form cease-and-desist letter. Collectors *despise* these letters—in part, because they are effective. For a short time.

THE CREDITOR'S PERSPECTIVE

The last bit of strategy that we can offer in this overview is to try to see the renegotiation process from **the creditor's (or collector's) perspective**. This will help you negotiate successfully.

For example: In the 1980s and 1990s, real estate lenders were quick to foreclose on non-performing loans. In the 2000s, though—with their non-performing asset portfolios overflowing—they were more inclined to work with borrowers in trouble.

This is an important point, worth repeating: A lender's interest in renegotiating a loan or contract with you usually has little to do with your circumstances and a lot to do with the lender's.

So, your **goal in a renegotiation is really twofold**: making a deal that you can live with...and making a deal that satisfies the lender's needs.

Prior to meeting with the lender, prepare materials making the case that modifying your deal is in *its* best interest. Explain why your current financial problems exist and outline a realistic game plan will ensure that the problems will be corrected and not recur. And **won't add more headaches to the lender's non-performing-asset portfolio**.

> Often, debtors come to the table as beggars, ready to accept any new terms offered by the lender. But accepting terms that will only delay a collapse is of no value to anyone. Identify ahead of time new terms that will allow you to make payments in a timely manner for the duration of the contract.

And one last point: Remember that in the cramdown era *everything* is renegotiable—interest rates, monthly payments, length of the loans, collateral, payment schedules, credit reporting and technical loan covenants (i.e., debt-to-equity ratios, etc.).

In the next nine chapters, we will take more detailed looks at various categories of assets and debts. And we'll discuss the fine points of how the cramdown era affects each of these.

CHAPTER 2

LOAN
MODIFICATION

Loan modification is a process whereby a home-owner's mortgage is modified and both the lender and homeowner are bound by the new terms of the mortgage. However, a "loan mod" is not a refinance; the same mortgage contract stays in place—its terms are simply adjusted.

The most common loan modifications are:

- lowering the mortgage interest rate,

- reducing the mortgage principal balance,

- fixing adjustable interest rates within the mortgage,

- increasing the loan term of the mortgage,

- forgiveness of payment defaults and fees,

- or any combination of the above.

In most cases, the reason a lender will agree to make a loan mod is to reinstate a late or defaulted loan as current under terms and conditions that the mortgagor can afford.

A loan mod and a refinance can achieve similar goals—such as lowering a mortgage rate and extending a loan term. However, a loan mod does not create a new home loan. People who refinance their home loans have to apply for a new mortgage, go through property inspection and title checks and pay various fees (including early termination fees); with a loan mod, the borrower works with his lender to change the terms of the existing contract.

There are no hard-and-fast rules for making loan mods. But most lenders look for some sort of hardship that the homeowner has suffered. The most common of these are:

- an **ARM** that has adjusted out of reach,
- excessive consumer spending (often financed by a succession of home refi's) ,
- unexpected medical bills,
- divorce,
- a death in the family,
- loss of job, etc.

Before the 2007 recession, mortgage professionals used to say that many—perhaps half—of delinquent or defaulted mortgages could be reinstated. So, the main "loss mitigation" tactics involved simple adjustments like adding the delinquent principal, interest, and fees on to the back end of the loan.

Borrowers usually had a financial incentive to work to keep the loan. Most had positive equity in their homes that they wanted to keep. By the end of 2008, all that had changed. With real estate prices

dropping all around the U.S., fewer homeowners had positive equity in their homes to protect.

And the newest delinquencies weren't caused by temporary hardships; most delinquent borrowers had never had enough income to cover their mortgage payments which reset (as scheduled) from "teaser" rates to full-amortization payments. These troubled loans would require a reduction in principal and interest rate for the borrower to service the debt in a consistent manner.

> In response to the record number of defaults and foreclosures in 2007 and 2008, many lenders have set up departments to handle loan modifications in a systematic way.

Still, mortgage lenders are not *obligated* to make loan modifications. Several factors determine whether a lender will modify a home loan. They usually take the borrower's credit history into account. Some also consider motivation—how hard the borrower is working to make the loan mod happen.

FDIC AND FHA PROGRAMS

In 2008, the Federal Deposit Insurance Corp. (FDIC) initiated a systematic loan modification program at IndyMac Federal Bank to reduce first lien mortgage payments to **as low as 31 percent** of the borrower's monthly income. Specifically, these modifications focused on the following changes:

- interest rate reduction,

- extension of term, and

- principal forbearance (but *not* reduction).

The program was designed to achieve affordable and sustainable mortgage payments for borrowers and increase the value of distressed mortgages by rehabilitating them into performing loans. The Feds planned to expand the program to other FDIC-insured banks by paying servicers $1,000 to cover expenses for each loan modified according to the required standards and—more importantly—sharing up to half of the losses incurred if a modified loan subsequently re-defaulted.

Other terms and conditions of the FDIC program:

- Eligible Borrowers: The program would be limited to loans secured by **owner-occupied properties**.

- Exclusion for Early Payment Re-default: To promote sustainable mortgages, government loss sharing would be available only after the borrower has made six payments on the modified mortgage.

- Standard NPV Test: In order to promote consistency and simplicity in implementation and audit, a standard test comparing the expected **net present value** (NPV) of modifying past due loans compared to the strategy of foreclosing on them will be applied. Under this NPV test, standard assumptions will be used to ensure that a consistent standard for affordability is pro-

vided based on a 31 percent borrower mortgage debt-to-income ratio.

- Reduced Loss Share Percentage for "Underwater" Loans: For LTVs above 100 percent, the government loss share would be reduced from 50 to 20 percent as the current LTV rises. If the LTV for the first lien exceeded 150 percent, no loss sharing would be provided.

Banks joining the program wouldn't be able to cherry-pick just their worst loans for modification. Participating banks would be required to undertake a systematic review of all loans under their management, to subject each loan to a standard net present value (NPV) test to determine whether it is a suitable candidate for modification and to modify all loans that failed that test.

Here are the steps that would be taken under the Making Home Affordable Modification Program to rework a loan for a household (say, a married couple) heading toward foreclosure:

- The couple must provide two recent pay stubs for each person and the latest income tax filing, an affidavit of hardship, and detail debts and fixed living expenses, such as credit cards, car loans, student loans, etc.

- The bank or servicer compares monthly mortgage payments with monthly income before taxes. If the couple's monthly debts exceed 55 percent of income, they must get counseling by a

federally approved housing counselor to get the modification.

- The federally set sequence of loan modifications starts with the goal of lowering the monthly mortgage payment to 38 percent of income before taxes.

- The interest rate is reduced to as low as 2 percent. Past-due charges are factored in and late fees waived.

- If the goal is still out of reach, the loan period can be extended up to 40 years.

- If the 38 percent is still unmet, part of the principal must be tacked on to the end of the mortgage and paid off in a balloon payment when the house is sold or the mortgage period ends.

- The mortgage lender or servicer could decide to reduce the mortgage principal to reach the 38 percent target.

- The federal rescue initiative offers incentives to go down to 31 percent by splitting the 7 percent difference with the lender or servicer.

- The couple is put on a three-month trial and, if payments are on time, the changes are fixed for five years.

- In year six, the interest rate can increase 1 percent annually—but can't be more than the market interest rate on the day the modifications were finalized.

- Mortgage lenders and servicers get financial incentives for modifying and

keeping loans on track, but borrowers get $83.33 for each on-time monthly payment, up to $5,000 over five years. The money goes directly to the servicer to reduce the principal balance.

Much as the FDIC used a loan mod program at IndyMac Bank (which it had seized) as the guideline that other banks could follow, the Federal Housing Authority (FHA) used its "Hope for Homeowners" program as a model for private-sector lenders. Understanding the FHA program will help you prepare for negotiating a loan mod with your lender.

The FHA loan mod program follows the terms and conditions described in HUD Mortgagee Letter 2008-21. Among other things, Letter 2008-21 instructs lenders that:

- Legal fees and related foreclosure costs for work actually completed and applicable to the current default episode may be capitalized into the modified principal balance.

- Accrued late charges should be waived by the lender at the time of the Loan Modification.

- The new interest rate should be no more than **200 basis points** (that's 2 percent) above the monthly average yield on U.S. Treasury Securities, adjusted to a constant maturity of 10 years.

- The lender may conduct any review it deems necessary to verify that the prop-

erty has no physical conditions which adversely impact the mortgagor's continued ability to support the modified mortgage payment.

- If a borrower is unemployed but his or her spouse who's not on the mortgage has a job, the lender "should conduct a financial review of the *household* income and expenses to determine if surplus income is sufficient."

MAKING YOUR OWN LOAN MOD

Late 2008 and 2009 were a boom time for "loan modification consultants." In many cases, these people had been loan brokers when the real estate market…corrected.

Do you need to pay a "consultant" several thousand dollars to negotiate your loan mod? No. Can you do it yourself? Yes. But you have to be patient. As one loan modification specialist wrote us:

> *On average I get denied on a file at least twice. I call the lender, state the case and they deny me. It's only after sound work and a "pitbull approach" that they work with me.*

First, contact a HUD-approved Housing Counseling Agency near you. These agencies do the most for people who have government-backed loans— but they can also help you if you don't. To find the agency nearest you, visit HUD's Web site at:

http://www.hud.gov/offices/hsg/sfh/hcc/hcs.cfm

These agencies typically charge nothing to help you.

Ask specific questions about your lender—what its local reputation is for doing loan mods, if there are specific employees to request, if there are particular words or phrases to avoid. Local HUD-approved agencies deal with lenders constantly and can usually give you a "scouting report" on yours.

Prepare in advance. Let your lender know up front, with documentation, what kind of payment you can afford. In most situations, this means assembling the paperwork *before* you call your lender.

PREPARING THE PAPERWORK

Before you get to the point of negotiating, a successful loan modification will involve a lot of paperwork. In terms of the amount of personal information you'll need to provide, the process is like applying for a new mortgage. Specifically, you'll usually have to gather the following:

- At least four recent pay stubs—for everyone in the household who has income.

- If you don't have pay stubs, you'll need a profit-and-loss statement or "cash letter" from the earner defining what he takes home monthly. (Although it may whine, a lender will accept this letter.)

- Three years of W 2's for each wage earner in the household.

- Three years of tax returns.

- Three months of bank statements. (Most lenders will want to see *all* pages of the statements. If you don't have them, go to your bank and get a three-month printout. Make sure that someone in the branch stamps and signs it.)

- If you are self-employed, you may need to have as much as two years of bank statements ready.

- All of your loan documents from when you originally purchased and/or most recently refinanced.

If you can't find your loan documents from the closing, you can get them directly from your lender. By federal law, the lender is required to send you every page that you signed at closing.

Next, gather all of your bills and make a complete list of your monthly expenses. Include everything you spend money on regularly, including:

- your current mortgage payment,

- other home maintenance (including association fees, etc.),

- groceries and food,

- regular health care expenses (prescription drugs, etc.)

- utilities (heating bills, electric bills, water bills, trash, sewer bills, etc.),

- all forms of insurance,

- transportation (car payments and main-
tenance, mass transit, tolls, etc.)

- child care,

- children's education and tuition (in-
cluding school lunches, activity fees,
uniforms if any, fees for sports, camps,
clubs, etc.),

- your own education and/or student
loans,

- pet maintenance and pet food.

Get your totals for income and expenses on paper
and compare them. You may be in the red—pay
more than you earn each month. That's actually
good, for the purpose of negotiating a loan mod.

Calculate what your new payment would be and do
the math again using your new modified payment.
If you are in the black with a reasonably modified
mortgage payment, you've just made the best ar-
gument for your lender modifying the loan.

**What you're doing (and the lender will be doing)
here is calculating your debt-to-income ratio. This
is the critical metric for determining what kind of
payment you can afford.**

One last bit of useful paperwork: If you've tried to
sell your home but had no success, this can be a
good negotiating point for getting a loan modifi-

cation. So, have copies of your property listing agreement with the real estate agent. This way, you can demonstrate that you owe, say, $300,000 on the mortgage but haven't received a single offer on a $280,000 listing price in three months. This **market pricing information** can help your case.

And **be patient** when conveying information. Expect documents and records to get lost or sent to the wrong offices as they're faxed back and forth.

CONTACTING THE LENDER

Once your paperwork is ready, you should contact your bank or mortgage company.

> **Many delinquent borrowers never have the courage to pick up the phone and talk to their lender before heading in to foreclosure. By some estimates half of owners in foreclosure never contact their lenders. This is incredibly wasteful.**

Identify yourself as a borrower (not an agent or consultant) and ask to speak with the **loss mitigation department**. Don't spend too much time with the customer service representative—they can't help you. Save your breath and make sure you're transferred to right department.

The loss mitigation department will usually start by asking you a series of questions—mostly about your loan. From these preliminary questions, the staffers will decide whether you're a good candidate

for a loan modification. If you are, they will send you an information packet along with a worksheet to calculate your monthly expenses.

Think of this process as the reverse of when you qualified for the loan; you need to "unqualify" yourself from the loan as it is...and prove that you need a modification in order to become a consistent, long-term payer. The best way to "unqualify" yourself is to establish some temporary financial hardship: a layoff from your job, an illness in the family, a divorce or other upheaval.

Lenders consider two main factors when reviewing a loan mod application: First, they consider the **terms of the loan**; second, they consider **your debt situation**.

They look for documentable hardship—but, if they agree to the loan modification, they *really* want to know that you can afford the new payment. If you are not able to **demonstrate an ability to make payments** after a reasonable modification (for example, a 30-year fixed-rate loan at 6 percent), you will not get one approved.

There are some insider tricks to "unqualifying" from the old loan and qualifying for the modified version. The main one: The income you can use to qualify for a mod is **different from income calculations** used to qualify for traditional loans. And this difference can work in your favor.

For a loan modification, you can qualify based on your documentable **total household income**. For this, you can count income from almost any source: grandma's SSI, income from a second job paid under the table, etc.—so long as it can be proved.

Once you calculate documentable monthly income from all household sources, you have what you can present to the lender as a new qualifying income.

To calculate a qualifying monthly mortgage payment, use the standard fully-amortizing 6 percent rate on whatever the new balance might be (to start, count past-due payments in the balance).

Most of the loan mod consultants we interviewed agreed on a few key points to keep in mind:

- never take your lender's first offer,

- never settle for a "workout agreement,"

- never accept a deferment or forbearance, as a solution in and of itself.

If your lender offers a modification:

- Make sure the mod reduces your monthly payment. Some don't. Some mods capitalize late payments, unpaid property taxes, etc., into a new amount. That doesn't do borrowers much good.

- Focus on the interest rate reduction. Few lenders will agree to reduce the

actual amount owed. But many will lower interest rates—and make adjustable rates fixed.

Some people say that extending the loan term from 30 years to 40 years is good. Others say that the additional interest paid over the life of the loan is bad. You have to make that call for yourself.

Some other tips:

- Understand which **items you can—and cannot—negotiate**. Late fees are highly negotiable. Interest rates are somewhat negotiable. Principle amounts are generally *not* negotiable.

- No bank is going to agree to a loan modification if you have **other real estate** assets. So, if you have a beach house, you need to sell it first.

- A crucial element to this whole process is **your budget**. Your budget will show a detailed account of your monthly expenses and income. If your budget looks too tight you may not get approved.

- Don't let the lender convince you to accept loan mod terms that barely change from the original contract—which is what many lenders will try, at least at first.

- Look out for anything like a "back-end yield spread" or "Service Release Premium." These are abusive fees that shouldn't appear on a modified loan.

- Don't agree to pay for mortgage life insurance, credit insurance or other expensive lender add-ons.

The employees at your lender are trained to extract as much money from you as they can; but they *don't* want you in trouble again six months after a loan mod. Understand this and you'll have some idea of how to speak with them.

Finally: in most loan mod agreements, the borrower **gives up his right to sue** for remedy of anything related to the origination of the mortgage. This is one of the key pieces of leverage that you have.

> **Your lender may have exposure to consumer-protection claims if it did anything questionable when the original loan was made. Some lenders will grant the mod just to get your waiver of those claims.**

LOAN MOD CONSULTANTS

As we noted before, so-called "loan modification consultants" have sprung up where loan brokers used to stand—on the seedy end the mortgage world. Often, they are exactly the same people.

Many loan mod consultants claim to deal with a "pool of attorneys." In most states, they need to say this in order to take money in advance for their services. But some consultants don't require payment in advance; if you're thinking about using a consultant or another so-called "expert," look for

one that expects to be paid only *after* he's provided some service to you.

According to the Federal Trade Commission, you should **avoid doing business** with any loan modification firm that:

- guarantees to stop a foreclosure, regardless of how much you owe or how much household income you can prove;

- tells you to avoid contacting your lender or servicers directly, delegating all negotiating duties to the firm;

- instructs you to send mortgage payments to its office address instead of to your lender or servicer;

- asks you to turn over the title or deed to the property so that the company can be in a "stronger position" to deal with the lender.

If you spot any of these red flags, take the FTC's advice: "**Walk away fast**."

Crooked loan mod companies operate in target-rich environments. In November 2008, the California state attorney general's office broke a crooked operation that collected up-front fees ranging from $1,500 to $5,000 from homeowners—and did nothing of value for the money. The crooks had collected more than $700,000.

How do these crooks convince people to hand over money that should be going to bring their mortgages current? Many use so-called "viral market-

ing" tactics; they post messages on Internet web sites and user groups, pretending to be homeowners who've had great results. Here are two examples:

> *I tried negotiating a loan mod with my lender, and I am a real estate agent. …They offered me 5.25 down from 6.25 and no balance reduction. However by paying a measly $3,995 I was able to get 2.9 fixed 30 years and my balance was reduced from 585K down to 480K. People, trust me, I know the modification company made money on me. But the point is you're going to get better results with an attorney backed modification company.*

> *My best friend tried to modify his loan with Wells Fargo for over 5 months and they rejected him twice a month when he called. …He hired a loan modification service and 40 days later his $4200 a month neg am loan payment (without impounds) is now $2200 WITH taxes and insurance AND the bank paid his 10k in past due property taxes!. His fully amortized rate was 8.3% now it is 3.4%. You tell me how paying $3500 for a service that let him keep his house AND save well over $2500 a month wasn't valuable?*

Never follow the lead of something like this that you read on the Internet…or anywhere else.

Loan mod service fees are usually based primarily on loan amount and secondarily the borrower's situation (just late, notice of default, or notice of trustee sale). Here are some typical fees:

- loan balance to $100,000—$1,250

- loan balance to $200,000—$1,995

- loan balance to $300,000—$2,795

- over $300,000—1 percent of loan amount

If you choose to hire a loan mod consultant:

- ask for references, make them show you examples of successful loan mod agreements;

- check with the Better Business Bureau and your local consumer affairs agency;

- negotiate your fees at the beginning but pay them close to a successful result as possible; and

- **call your lender** at least once a week to keep track of what activity is going on your account.

Even though you are not negotiating yourself, you should still make sure the person you hire is in constant contact with the bank.

And make sure that anybody who is going to work for you knows about:

- **Pooling and Servicing Agreements** (PSAs), the complicated secondary-market contracts that can make subprime loans difficult to modify;

- the **Real Estate Settlement Procedures Act** (RESPA), which regulates loan origination and controls how brokers and consultants are paid;

- the **Truth in Lending Act** (TILA), which requires lenders to make the terms of their loan clear to borrowers;

- the Home Ownership and Equity Protection Act (HOEPA), which limits fees that can be added to loans; and

- **Regulation Z**, a Federal Reserve Rule that helps enforce TILA and prohibits various type of predatory lending.

If you get a blank stare when you mention any of these items or laws, end the meeting. And find another consultant.

Some crooked loan mod salesmen will tell you to stop making mortgage payments and pay their fee, instead. Or they'll tell you to put the up-front fee on your credit card. Both approaches are wrong.

Most leading merchant services companies prohibit the use of charge cards for loan modification services. In other words, you usually *can't* use a credit card to pay advance fees. However, some bad actors figure out ways around these barriers.

LOAN MODIFICATION HURDLES

This book is focused on practical aspects of renegotiating debts. But we can't discuss loan mods in an informed way without discussing the effects of loan securitization—which played a part in the real estate bubble of the 1990s and early 2000s.

In practical terms, **securitization** (dividing owner-
ship interests in a portfolio of mortgages and reor-
ganizing them as riskier and less-risky investments)
makes it difficult to know who the owner of an in-
dividual mortgage actually is. The PSAs, which we
first mentioned a couple pages back, are the tools
that allow a servicing firm to collect your mortgage
payment each month and distribute portions of it
to different investors—who own **different inter-
ests in your loan**.

You may believe that the company servicing your
loan is your lender. In fact, it may just be moving
money around for several different investors.

As a result, some "lenders" may not be in a position
to renegotiate loans. And even *their* loss employees
may not realize this. The result can be mixed sig-
nals and confusion. One consumer complained to a
Seattle-based real estate industry Web site:

> *Nationstar sent me modification docs in June, I*
> *signed and had notarized on 6-26-08... It was*
> *interest only payment for 2 years then payment*
> *with escrow for approx. 2,800... Then*
> *{Nationstar} had changes... they wanted 3,200*
> *without escrow included, I said too high... Now*
> *they have one they want me to sign for 2,756*
> *plus escrow to have payment at 3,703.61 per*
> *month starting 10-01-08...*

This is the deepest downside of securitized lend-
ing: When the loans are modified, there's more than

just the lender (or, actually, servicer) who has to agree to the new terms.

Most financial industry professionals consider servicers the nexus of the problems that caused the 2007-2009 real estate market collapse. And many finance pros have a skeptical opinion about *anything* a servicer reports about the status of a loan or loan mod application.

> So, be prepared. Your "lender" may in fact be a servicer. And your servicer may make promises about a loan mod that it can't keep.

THE LENDER'S PERSPECTIVE

Still, *someone* owns your mortgage. And that someone—even if it's a Wall Street hedge fund—would rather have your mortgage **generating reliable monthly payments** than getting locked up in foreclosure of other legal proceedings. We'll end this chapter by looking at loan modification from a lender's perspective.

Lenders don't like foreclosure because that means months of not collecting any cash-flow from the loans. But, they may be quicker to foreclose on a home that has a lot of equity in it; they may think they can sell *that* home for a profit, even after all of the legal fees, etc.

So, a person with little equity in his home has some advantages in negotiating a loan mod. Lenders don't

want to repossess properties that won't sell for a profit...or will sit on the market for many months.

Remember: Loan mods aren't designed to help borrowers (at least not *primarily*). And you shouldn't believe any sales spiel that suggests they are. Loan mods are designed to help lenders avoid ending up with too many non-performing loans.

A portfolio of non-performing loans at an average of 8 percent interest being turned into a pool of performing loans at 5 percent interest is **a much better prospect** than foreclosing, going a year with no cash-flow, paying various legal fees—and facing the prospect of a capital loss of 25 to 40 percent on the properties when they finally sell.

Let's turn the focus back, again, to one homeowner.

Jack bought a house in 2005 for $400,000 with a zero-down, 8 percent mortgage. Three years later, the house is worth $300,000. And Jack's struggling to make the payments. He can't refinance because he already owes substantially more than the house is worth. Taking advice from his brother-in-law, Jack decides to "walk away."

But he walks away slowly. He stops making mortgage, insurance and property tax payments. Three months go by. His mortgage company sends threatening notices. When Jack is five months behind, the lender starts foreclosure. This takes 90 days to complete. Finally, some eight months after he

stopped paying his mortgage, Jack gets an eviction notice. And he still sticks around a few weeks before he moves to a rented apartment.

In the meantime, Jack's lender has lost interest payments that should have totaled nearly $30,000. And it has to make insurance and property tax payments that mean thousands more. Plus, it has to pay lawyers and a title company to execute the foreclosure. Its total expenses are more than $50,000.

The market price on the property is $300,000. But buyers in a down market are smart; they cap their offers at $270,000. That's $130,000 less than what the lender loaned Jack. By the time the house sells, the lender has lost some $180,000 in a little less than a year on Jack's $400,000 loan.

On the other hand, if Jack's lender had modified his $400,000 mortgage at 8 percent (payments of about $2,700 a month) to 5 percent (about $1,000 a month less)—and Jack made those lower payments reliably—the lender would have lose about $12,000 in interest over the same period.

A loss of $180,000 versus a loss of $12,000. That's the *real* reason loan modification exists.

CHAPTER 3

FORECLOSURES, SHORT SALES AND OTHER TOUGH SITUATIONS

The recession that started in 2007 had a brutal effect on the American real estate market. Foreclosure filings were reported on more than 2.3 million American properties in 2008, according to the industry data service RealtyTrac—an 81 percent jump from 2007. And the first few months of 2009 suggested that year would be worse. Some details:

- In March 2009, the Mortgage Bankers Association reported that more than 11 percent of mortgages were either past due or in foreclosure during the fourth quarter of 2008. That meant more than a million homes were in foreclosure.

- Nearly half (48 percent) of the nation's homeowners who had a subprime, adjustable-rate mortgage were behind on their payments or in foreclosure.

- A record 5.4 million American homeowners with mortgages, or nearly 12 percent, were at least one month late or in foreclosure at the end of 2008.

Many of these tough situations could have been avoided if the homeowners had communicated more clearly with their lenders or loan servicing firms. There's something deep in human nature that avoids communication when facing troubles…especially money troubles.

This is the opposite of how things should be. It's precisely when you're having problems that you *should* contact your lender. If the recession of 2007 established anything, it is that foreclosures are bad for homeowners *and* their lenders. And lenders will do a lot to avoid foreclosures.

> There are various estimates of how much an "average" foreclosure (if there can be such a thing) costs a lender. But the averages cluster between $50,000 and $70,000 per property. Few banks can afford many of those losses.

As we noted in the previous chapter, the most common factors that cause foreclosure include:

- rising adjustable-rate mortgages,
- unemployment,
- divorce,
- illness or disability,
- reckless discretionary spending.

During the 2008 recession, the first and last of those factors loomed especially large. Many Americans had refinanced their homes to cover consumer

spending habits...and paid little attention to the details of the interest rates on the loans. And many focused—foolishly, as it turned out—on the introductory "teaser" rates on the loans. These artificially-low rates often lasted 24 months, before the actual adjustable rates took effect.

During a booming real estate market, homeowners could simply refinance their mortgages every two years and avoid the adjustment. The collapse of the subprime loan market in 2007 made that kind of borrowing impossible. So, the homeowners had to face the adjustments—sometimes boosting monthly payments by 50 percent or more.

A home foreclosure damages your credit—almost as much as a bankruptcy; and it can remain there for up to seven years. If you have a foreclosure on your credit report, you're likely to have a difficult time getting any type of new credit, from a credit card to a new mortgage.

We've already considered the details loan modification. Short of a loan mod, most solutions to a pending foreclosure involve one of two strategies:

- a short-term (less than 90 days) plan for bring the loan current; or

- some manner of exit strategy from the house in question.

In this chapter, we'll consider the details of each of these strategies.

ECONOMIC BACKGROUND

Some economists attribute the real estate boom of the 1990s and early 2000s to the lenders trying to apply the "credit card model" to home loans.

> **The "credit card model" refers to aggressive lending in which some U.S. banks engaged during the late 1980s and 1990s. These banks gave credit cards to borrowers who would have been traditionally considered unqualified—because the overall default rates on credit card-based loan portfolios were low enough that the bank could write off many accounts and still make a profit.**

These default rates remained low through the 1990s and 2000s. Why? Well, many reasons. The most important was that housing prices were rising sharply enough that people who would otherwise have defaulted were able to **refinance their homes to consolidate their credit card debts**—rolling the credit balances into the amounts they owed on their houses and "freeing up" the cards for more use.

In addition to the refi mania of the late 1990s and 2000s, more general factors keep Americans paying their credit cards bills. It's a secret of the credit card business that people who use cards heavily will struggle with debt balances longer than logic would suggest they should. Why? Because many "middle class" households borrow more on the credit cards than they admit to themselves and their family or friends. And they don't want to admit publicly—

bankruptcies and foreclosures are public events—that they were living beyond their means.

> If Americans fight so hard to keep their credit cards working, it's rational to suppose they will fight even harder to keep their home loans current—or at least out of foreclosure. Mortgage companies followed this logic to the point of marketing home loans to people who barely qualified for them.

Based upon underwriting guidelines and risk profiles, a loan could be produced that—in theory—would provide an acceptable return based upon the associated risk. The important questions were:

1) What is the risk associated with a particular underwriting profile?

2) What is the required rate of return required in order to offset that risk?

Every loan type has an expected default rate for which the associated cost is **spread over the total number of loans in that category**.

If lenders had charged high enough interest rates (20 percent per year...or higher, some cases), they might have been behaving rationally. But they didn't. Home loan interest rates—subsidized by federal regulations and tax policy—stuck stubbornly below 10 percent.

Economists would later conclude that government policies and a handful of the biggest lenders over-

estimated the value of the "security" that comes with home mortgages. As a result, they discounted mortgage risks too much.

Discounting risk is a dangerous game. And the competitive pressures of the market often add a "slippery slope" quality to the whole process. So, in the 2000s, mortgage lenders were selling loans to people who barely qualified (risk exposure #1) and pricing them at lower interest rates than pure underwriting would suggest (risk exposure #2).

> As long as the real estate markets continued to rise in value, these exposures remained hidden by the rising tide. As soon as prices started to drop—even slightly—the problems became obvious. And the number of foreclosures took off.

FORECLOSURES AND POLITICIANS

The leap in foreclosures frightened voters enough that the politicians decided to "do something."

In July 2008, the U.S. House of Representatives passed the American Housing Rescue & Foreclosure Prevention Act—which was supposed to use $75 billion in government funds as part of the "Making Home Affordable" plan. This plan would help families facing foreclosure keep their homes.

A separate bill would prohibit non-HUD- approved agencies from providing foreclosure assistance. That bill defined "foreclosure consultant" as:

a person who makes any solicitation, representa-
tion, or offer to a homeowner facing foreclosure on
residential real property to perform, for gain, or
who performs, for gain, any service that such per-
son represents will prevent, postpone, or reverse the
effect of such foreclosure...

While the bill presented opportunities and resources for bona fide HUD-approved counseling agencies, it limited the participation of other agencies in the foreclosure-counseling business. Regulatory and enforcement authority over "foreclosure consultants" was granted to the Federal Trade Commission.

The goals of these laws were complex—even impossible. While the $75 billion budgeted to the ARRA plan was intended to help change the loan terms for up to 9 million homeowners, unemployed borrowers (who, arguably, needed help the most) would have a hard time qualifying.

The basic qualification requirements for the "Making Home Affordable" program:

- owner-occupied, principal residence;

- encumbered by a mortgage that had originated before Jan. 1, 2009;

- the loan's monthly mortgage payments exceeded 31 percent of the homeowner household's gross monthly income;

- the homeowner household must have undergone some type of demonstrable financial hardship—such as a loss of income—that put it at risk of default.

These rules meant that tens of thousands of homeowners in some of the worst-hit real estate markets—states like California, Florida, Nevada and Arizona—wouldn't be eligible for the programs.

In December 2008, Rep. Barney Frank told CNN that if the Treasury Department wanted a second $350 billion installment of bank bailout money, it would have to come up with a foreclosure workout plan—one that included "principal write-downs." This met with *major* resistance from lenders and mortgage investors.

> Banks took less-dramatic steps. Some followed Citigroup's plan—which lowered mortgage payments for borrowers to as little as $500 a month for three months if they were out of work. But these programs offered short-term help, not the structural changes that elected officials wanted.

Politicians can't just call a halt to foreclosures. In early 2009, nearly half of the U.S. homes in foreclosure were located in six states. But those states were undergoing different types of reckoning.

California, Florida, Arizona and Nevada had been hit by a hangover after a home-building boom that had lasted more than a decade. That boom had been fueled by rising home prices and people using risky mortgages to buy properties as investments. Those four states had nearly 400,000 homes in foreclosure—a third of the nationwide total.

The other two states hit hard by the crisis—Michigan and Ohio—had more traditional economic woes stemming from job losses, particularly in the automotive sector. The foreclosure rate in each of those two states was near 4 percent.

Normally, real estate markets move slowly. The fast increases of the late 1990s and early 2000s were an anomaly—that resulted in faster-than-usual declines in 2007 and 2008. When home prices had fallen so far from the market's peak, finding solutions to keeping homes out of foreclosure was difficult.

Politicians can *say* whatever they like; they can't change the economy. Sometimes, bad results are inevitable—and inescapable.

DEED IN LIEU OF FORECLOSURE

If you ask, some real estate experts will mention a "Deed in Lieu of Foreclosure" as the most effective way to deal with a home investment gone bad.

A deed-in-lieu is easy to understand. The homeowner **simply signs the deed to the mortgaged property over to the lender**, which can immediately set about reselling. This is faster than a foreclosure, so the lender doesn't lose as much time. And it seems more straightforward...even honest.

But it's not always so simple—or so good for the borrower. First of all, **a lender doesn't have to accept a deed-in-lieu** offer. (And some lenders have

of policy of not accepting them.) Doing so reduces the lender's ability to pursue the homeowner for a **deficiency judgment** later—if the property ends of selling for less than the loan amount or the lender concludes there's been some sort of fraud on the part of the homeowner.

> It often makes most sense for a homeowner to "send back the keys" when a home is significantly under-water. This is also the time when the lender has the least incentive to accept the deal. So, if your prop-erty has major negative equity, you should defi-nitely contact the lender before sending keys.

Most banks/servicers look over the file very care-fully when a deed and keys arrive in the mail from the homeowner. Many talk about fraud as a major issue with deeds-in-lieu. The scams range from owners stripping the houses of appliances and plumbing to fraudulent borrowing of multiple mortgages against a single property.

Still, some lenders prefer a deed-in-lieu to a drawn-out foreclosure. And the deal can be especially ef-fective if the foreclosure process has already started. If the Trustee Sale (the last stage of formal foreclo-sure) forgives any shortfall, a deed-in-lieu just prior to sale can be a labor-saving option.

Some lenders require certain facts to be established before they will accept a deed-in-lieu. These pa-rameters may include:

- proof that the property is owner-occupied, not a "walk-a way" or investment property;

- proof that the homeowner has tried to sell the home for fair market value for at least 90 days;

- documentation of a reduction in income or an increase in living expense—which verifies the borrower's need to vacate the property;

- evidence that utilities, assessments and homeowner's association dues are paid in full to the transfer date.

A caveat: The deed-in-lieu option may not be available if you have other liens—such as creditor judgments, second mortgages or IRS and state tax liens.

Still, the deed-in-lieu does offer some advantages over a formal foreclosure:

- The borrower avoids the public notoriety of a foreclosure proceeding.

- In exchange for the deed-in-lieu, the lender may waiver all deficiency judgment rights.

- It negatively affects your credit rating—but less than a foreclosure does.

In most cases, a deed-in-lieu will stay on your credit for four years from the date the deed-in-lieu is ex-

ecuted. And mortgage lenders will generally consider doing business with you again four years after a deed-in-lieu (assuming you don't have other credit problems in the meantime). They may, however, require a larger-than-standard down payment.

One final caveat: Do not—under any circumstances—add anyone to the title of your property in the course of a deed-in-lieu exchange. Only you and the lending institution should be involved.

Some swindlers get involved as "consultants" in these transactions and, at the last minute, convince the homeowner to sign over the property to *them* instead of to the lender. This is why it bears repeating that no one other than the lender should be involved in the transaction.

SHORT SALES

A "short sale"—or pre-foreclosure sale—allows the homeowner in default (or, in some cases, near it) to sell his home and use the sale proceeds to satisfy the mortgage debt, even though the proceeds are less than the amount owed.

If other foreclosure alternatives aren't likely to succeed because of your financial situation (or if you don't want to retain ownership of the property), the short sale may be an acceptable option.

Like a deed-in-lieu, a short sale must be approved by your lender. And this can be a little more com-

plicated, because you have at least three parties involved (you, the buyer and the lender) in the deal—instead of just you and the lender.

The main advantage of a short sale over a foreclosure is that you avoid having a foreclosure on your credit report for 10 years.

If a short sale is negotiated properly with your lender you can avoid a possible **deficiency judgment**. (A deficiency arises when a property sells for less than the amount its mortgage.) So, early in the process, you should ask whether your lender will accept the short-sale proceeds as full satisfaction of the debt.

Obviously, if your lender waives its rights to deficiency judgment, a short sale becomes a lot more attractive to you. But **most lenders won't agree in advance**; they'll take a wait-and-see approach, until you have an offer in hand and they know more clearly how much they stand to lose.

If your local real estate market has a lot of foreclosures or "bank-owned" properties, a short sale—like any sale—can be difficult. But a short sale can have some advantages in a weak market: your lender is more likely to agree to a reasonable offer; and the short sale can go through the escrow or contract process in a conventional way—rather than the "as is" sales that foreclosures always are.

Some lenders prefer a short sale to a loan mod or other adjustment. Make sure to speak (first) to a

local HUD-approved mortgage counselor and (then) to the loss mitigation department of your lender—and ask candidly about the lender's position on loan mods versus short sales.

Some lenders are so averse to making foreclosures that they will accept short sales that are substantially...short. For example: During the low points of the 2008 real estate markets in Texas and other southwestern states, lenders like Homecoming Financial/GMAC were agreeing to sale prices as low as 90 percent of then-current "fair market value." In some cases, this translated into short sales for two thirds of the existing loan amount.

If you're considering listing your house as a short sale, here are some other points to consider:

- While a short sale is, generally, less damaging to your credit than a foreclosure, it still leaves a bad mark. If your credit is already banged-up, this may not make much difference; but, if your credit is still good, you may want to keep pursuing other options.

This point deserves some further comment: The definitions of excellent, good and poor credit have changed considerably in the 2000s. It's hard to predict what "good" credit will be in the next few years or the next decade.

- You may have more room to negotiate if you fight aggressively in foreclosure.

In 2008 and 2009—when the U.S. real estate market was flooded with foreclosures—some homeowners were able to make deals to stay in their houses quite late in the foreclosure process. In fact, some experts say that's the *best* time to make a deal. But it's a **risky strategy**; you may well lose the property.

- Do you **expect your financial situation to improve** as the economy improves or are you on a fixed income or one that will decline regardless of current events? If you finances should recover, you may want to make that case to your lender—and stay in the house.

- Some lenders indicate they'll support a short sale but then have a strict (or impossible) notions of what's "reasonable" when you present them with sales to approve. It is a common complaint that **lenders "undermine" short sales** as if to push the property into foreclosure.

There are two ways—both drastic—to respond to a lender that won't approve a short sale. One is to let the property go into foreclosure; the other is to file bankruptcy (usually, the Chapter 13 variety) and have a trustee approve the sale.

But both of these solutions defeat the purpose of a short sale—namely, minimizing financial damage.

AGENTS AND SHORT SALES

It can be a challenge to find a good real estate agent to represent your property in a short sale. But, as

with any real estate transaction, an effective agent can add a lot to a successful deal.

Some real estate agents specialize in short sales—and are experienced in the complex, multiparty negotiations that can be involved. Look for a short-sale specialist in your area; if you can't find one, contact standard realty firms and ask for someone with short sale experience.

Be honest and up-front about your circumstances and needs from a sale. You can speed things up considerably by explaining at the start that you understand the basic terms of a short sale...and that you believe it's your best option.

Realtors have to disclose short sales in their multiple listing system so other members of the MLS know whether or not the home sale must be approved by the lender.

In some states, realtors are required to ask a series of qualifying questions to make sure you understand the mechanics and possible legal or financial impacts of a short sale. These questions are designed to educate you—and also to give the realtor a paper trail that proves he made all necessary disclosures.

Most states have some form of Distressed Homeowner Law. These laws put a legal burden on agents to educate sellers about everything that can go wrong in nonstandard transactions. The laws have, effectively, scared many agents away from short sales.

The real estate agent handling a short sale needs to be able to understand your financial situation, your lender's portfolio strategy and a potential buyer's attitudes. Handling all this information, the agent may seem to be acting like an attorney. But she's not...and this is a sore subject for some people.

When it comes to real estate agents working with you on a short sale, there's some mumbling about "unauthorized practice of the law." But this is mostly the bureaucratic mania for regulation—and the frayed emotions that many short sellers have.

> In most states, licensed real estate agents have what's called a "limited scope authority" which does allow them to discuss the mechanics of short sales and even prepare certain standard forms that have been vetted by attorneys.

According to one west coast short-sale specialist:

> I do talk to my prospective clients about their financial situation. If they feel they have the income to support their monthly payment over a long period I refer them to free credit counseling. ...I also refer them to a bankruptcy attorney as a routine part of our first meeting. Many are buried in mortgage payments and have tapped savings, retirement, and credit cards to try to keep their home and are out of options.

Sounds about right. A good agent will help you manage a short sale—and that help is important.

TAX CONSEQUENCES

If you are able to execute a short and get the lender to waive its right to a deficiency judgment, you have accomplished a lot—but you may liable for income taxes on the difference between the sale price and the original loan amount. (This can hold true for some foreclosures, too.)

> For example, Jack has a $600,000 mortgage on a house that he short sells for $500,000. His lender takes the sales proceeds and releases Jack from the loan. Now, Jack has to pay income tax on the $100,000 difference.

The tax owed on the debt relief is based on the your income tax rate—not the capital gain rate (which is usually lower, naturally).

Still, a short sale is better than a foreclosure. The Federal Housing Authority allows compliant loans to be made to borrowers two years after a short sale; it makes borrowers who've had a foreclosure wait five years (and makes various special demands, even then). Many lenders follow FHA guidelines. So, a short sale is usually worth the work required.

OTHER FORECLOSURE OPTIONS

There are several other alternatives that you can choose if you're facing foreclosure of your home. While these may not be the best strategies for long-

term financial well-being, they can help you live to fight another day.

A **workout agreement** divides up the arrears balance and spreads it out over several payments until the borrower catches up. In this program, also called a **"repayment plan"** or "reinstatement plan," the lender will generally offer terms of 12 months for you to repay your past due amount. You'll be required to make the regular monthly payment plus 1/12 of the past-due amount each month.

For example: If your total past due is \$6,000 and your regular monthly payment is \$1,000, then your monthly payment on a Repayment Plan will be \$1,500.

In other workouts, the lender may offer to move the past-due payments (and late fees) to the end of the existing loan. This solution resolves the immediate crisis—but doesn't address whatever underlying issues got the borrower into trouble in the first place. In some cases, the borrower feels like the weight of the world has been lifted off of his shoulders, only to realize three or four months later that he still can't sustain the payments.

For this reason, some mortgage professionals call workouts **"a re-default waiting to happen."**

Still, if you've experienced a short-term financial hardship and are reliably back on your feet, a repayment plan can be an viable alternative to fore-

closure. And lenders will usually agree to these plans more readily than full loan modifications.

A caveat: Your lender or loan servicing company may not have *your* best interest in mind by putting you on a repayment plan. These plans are sometimes tricks that lenders and—especially—servicing companies use to keep delinquency rates (which they have to report to regulators) artificially low.

For example, a loan classified as 30 days past due will not progress to the 60-day category as long as it is on a repayment plan.

Repayment plans are used particularly to obscure the number of 90-day-late loans in a lender or mortgage company's portfolio.

Another reason lenders like repayment plans is that they can be used as a tool for "triaging" troubled borrowers. If the home-retention staff is swamped, it can offer repayment plans. Troubled borrowers go away. Some stay away—able to complete their plans. Others (the lender hopes *fewer* others) come back in six or 12 months looking for help again.

Regardless of your lender's reasons for offering you a repayment plan, make sure you've resolved whatever financial problems got you into trouble in the first place before you agree.

Under a **loan forbearance** agreement, your lender allows you to reduce or suspend payments for a short

period of time—and then you will agree to another option to bring your loan current.

> **A forbearance agreement is often combined with a reinstatement plan.**

Like a reinstatement plan, a forbearance only works if you know why you got into trouble—and are certain that you'll have enough money in a few months to bring the account current. Otherwise, it will just delay the inevitable foreclosure.

Finally, if you have an adjustable-rate mortgage that's reset to an impossible payment, you can try to **refinance** into a fixed-rate home loan. This will be difficult if you've already missed some mortgage payments or have other credit problems. But it's usually worth a try. To do this, get a copy of your credit report; if your rating is 680 or higher, a refi is probably a good option. Then, find out whether your mortgage is owned or guaranteed by Fannie Mae or Freddie Mac—they have programs to refi people with damaged or poor credit.

A caveat: Some homeowners in foreclosure or seriously delinquent try to refinance their existing home loan in an attempt to lower their monthly payments or get enough cash out to pay off past-due balances.

This is a poor strategy. Here's why:

- Your new loan will likely have a higher interest rate than your existing loan.

- The new loan will also come laden with points, fees and other added costs that will make the deal even worse.

- Paying off your existing mortgage may result in steep prepayment penalties.

- You may end up spending valuable time trying to qualify for a loan that you end up not getting.

If you have enough equity in your home, you may be able to arrange a so-called "private money" or "hard money" Second Trust Deed.

Hard money loans are based on equity instead of credit scores. They can be useful for self-employed borrowers who have difficulty substantiating income. To qualify, in most cases, the loan to value ratio (LTV) on your mortgage needs to be less than 70 percent. And you can't have tax liens or other encumbrances on the property.

With a Second Trust Deed, your first mortgage stays at its current interest rate and you pay a higher rate only on the smaller second loan. But, as with bad-credit refi's, the points and fees that second-mortgage lenders charge are even *higher* than the already-high interest rates.

> **And second mortgages (like other bad-credit loans) only delay the reckoning if your underlying cash-flow problems remain.**

CREDIT CARDS

Mortgage modifications may have generated most of the headlines in recent years—but credit card debt generates most of the negotiations...and renegotiations...in personal finance matters.

> If you're having money problems, credit card debt is usually the best place to start your efforts at renegotiating the amounts that you owe.

The most common choices people make when seeking debt relief:

- call the credit card company about your situation—only to find them not sympathetic to your problem; and

- apply for a loan to get a lower monthly payment and get denied because you are high risk and have too much debt.

The truth is that both of these steps usually come too late in process. You need to start the talks be-

fore the debt is sent to "collections." If your account is with the "original creditor," it's still being managed by the credit card company—and not a collection agency. This distinction is important because **different negotiating tactics work best** for a credit card company and a collection agency.

In most situations, a credit account will go to a collection agency if you haven't made a payment to or communicated with the original creditor in 120 days. And most credit card companies will refuse to talk to you once your account is "in collection."

A caveat: The timeframe for assigning delinquent credit card accounts to collections has been creeping closer in the late 2000s. It used to be about 180 days...and it's moving in toward 90 days. So, don't count on having 120 days to do nothing with your credit card account.

There's a narrow window of opportunity here. Calling the original creditor is the best way to the best way to negotiate a settlement quickly and effectively. However, most credit card companies won't negotiate with a debtor until an account is at least 60 days past due. So, if you want to negotiate a settlement with your credit card company, you need to move quickly—during the tight space **between being 60 days late and before the company assigns your account** to a collection agency.

With some companies, the window of opportunity can be as small as a week or two. If you're going to

reach a settlement with the company, you need to move quickly in this tight timeframe. And in this time, when you contact the card company about making a deal, keep these points in mind:

- If you've been paying on time and suddenly call up the credit card company looking for a settlement, the company is going to be suspicious. In this narrow context, a history that includes *some* late payments will help swing a deal.

- If you're current on everything but this particular card company (and the company will check your credit report), it's less likely to reduce your debt.

- The best way to convince a card company to agree to a settlement on your account is to make the credible case that this is its best chance to receive anything. So, you need to make your immediate future sound grim.

- If the card company doesn't think that you have many assets—real estate, being the usual example—and it won't be able to collect anything from a lawsuit, it's more likely to make a deal.

The first point raises a common question: Should you **stop paying your bills to convince a card issuer to settle**? This is a dangerous strategy. You'll damage your credit score in the process. But some people have used the strategy successfully.

Through the 1990s and early 2000s, credit card companies were reluctant to give customers settle-

ments that went below 60 percent of the amount owed. But the late 2000s recession changed this; some big card companies started offering settlements of 50 cents—and even a little less—on the dollar.

Don't be afraid to start low with your offer—you should *definitely* be the one to start making offers. In many cases, credit card company employees are trained not to make settlement offers. However, once you've started the negotiation (for example: "I understand this account balance is $10,000. I don't have that much money—but I am prepared to settle this account today for $5,000"), many are authorized to accept certain offers.

Some other tips:

- You don't need anything in writing from the original creditors in order to accept a deal. As a matter of fact, they will usually refuse to give you anything in writing.

- Credit card companies are highly regulated, much more so than the collection agencies, and they are, as a result, much more ethical.

- If you pay in full, you can get a "Paid as Agreed" rating, otherwise, "Settled" is the best you can do.

In recent years, credit card companies have adopted an immovable stance on your account rating if you settle for less than is owed. They will agree to list your account as "Settled"—but that's it. You can try to negotiate a better rating, but your chances there are slim.

Remember: "Settled" is better than "charged off" when it comes to your credit rating.

COLLECTION AGENCIES

Credit card companies have long been known for their aggressive use of collection agencies. They use "collections" for two reasons: maximize the performance of past-due accounts and intimidate people.

> **To make sure your account doesn't go into collection, don't let your payment get more than 90 days past due. American Express will typically send your account to collection after 90 days. With everyone else, you are in dangerous waters after 120 days.**

If you're intimidated by the prospect of calling a credit card company, you could try Consumer Credit Counseling Services. (Still, you may get a better deal if you handle things yourself. A CCCS's main goal is a worthy one; but its staffers often don't negotiate how an account will be reported—which could leave you debt free, but with ruined credit.)

In many cases, after seeing a credit report and some preliminary information, a creditor will make a high debt settlement offer—something like 75 cents on the dollar. Before accepting a lower settlement, they might demand further evidence of your financial hardship—including financial statements indicating income and assets. With evidence in hand proving the person's lack of ability to repay the debt, the creditor may consider a deeper debt reduction.

Following this pattern, **most negotiated credit card debt accounts settle in a range of 30 to 50 cents on the dollar**. Occasionally, they settle for 20 to 30 cents on the dollar—and, in rare cases, they can settle for less than that.

What determines the amount of settlement? The details of your financial situation have the most important effect on debt settlement figures. After that, the next most important factor is the internal debt settlement policy of the creditor with which you're negotiating.

Internal policies are hard to predict—and the federal bailout of commercial banks during 2008 and 2009 only made the predictions more difficult. For example: BofA, American Express and Citicorp are all major players in the credit card industry—but their policies on debt settlements are all different.

> **Knowing how each of these banks approaches settlements is one of the biggest advantages that professional debt settlement firms have over individual consumers negotiating by themselves.**

But there's a tactical approach from game theory that might help here: When you're not sure what your opponent's strategy is, **try asking**. In many cases, parties to a negotiation will be willing to "show their hand" in the belief that this helps reach an acceptable conclusion most quickly.

With most settlements, you need pay off each credit card debt at once in a lump sum—paying the creditor the reduced debt settlement figure to which it has agreed. There are **two exceptions** to this rule:

1) creditors may agree to a short payment plan, especially for larger amounts of credit card debt. These plans may range from three to six months;

2) debt management companies may arrange to stretch debt settlement plans out of a period of one to four years.

CREDIT CARD DEBT WORKOUTS

Workouts are the most common form of credit card balance renegotiation. In a workout, the credit card company writes off part of the amount owed and accepts a payment schedule for the remaining balance. So, there are two points being negotiated:

1) the amount of the balance owed that's been charged off, and

2) the terms of payment on the remaining balance.

Some lenders focus on one of these points and negotiate it more aggressively than the other. Likewise, some CCCSs and debt-management firms are better at helping you with one point and weaker on the other. But *both* points need to be resolved well to make a workout worth pursuing.

Caveat: If you have good credit, you should consider a workout as a last-resort option. The charge-

off portion of the deal will damage your credit—and may damage it severely.

On the other hand, if you already have multiple accounts on your credit report that have been charged off by lenders, settling numerous smouldering accounts as parts of **a coordinated workout plan** may actually improve your credit. This doesn't mean it will make your credit *good*; it means it will raise it from *very bad* to just *bad*.

If you hire (or even just meet with) a debt-management firm, its staffers or "consultants" will usually recommend a workout plan that settles all of your debts in a systematic process. And this is an area where debt-management firms can do some good. Some lenders don't take the situation as seriously when a borrower calls to negotiate a settlement as when a professional—most often, a bankruptcy attorney or debt-management firm—calls.

How do the debt-management firms that help you set up workout plans get paid?

On average, fees charged by credit card debt-management firms range from **eight to 15 percent of the total outstanding debt**. Some firms will calculate their fees based on what they save you through their negotiations with the card companies; these fees usually range from **25 to 33 percent of the savings**.

Terms of payment vary widely. Some firms require payment in advance, some allow payments over time and some require payment only after accounts have been settled.

Most credit card workout plans will provide both for payment to the creditors and payment to the debt-management firm. Payment to the debt-management firm can be on a flat-fee basis, calculated as a percentage of the total debt or a percentage based on the money saved through debt settlements.

Who holds the money that you're accumulating to pay off your debts? Sometimes you, sometimes the debt-management firm. Holding the settlement money yourself eliminates any worry that a stranger will mishandle them or abscond with it. On the other hand, for many people, the greater danger lies in holding the money themselves—because they will use it for other purposes.

Whether you or the debt-management firm holds the money, the strategy is the same: Keep the money in escrow until a particular credit card debt can be paid off at the negotiated rate. Settle that account. Repeat until all credit card (and other unsecured) debts in the workout plan have been paid off at the settled rates.

Who decides which debts to settle first? You and debt-management firm will work on this together—setting a priority list among your creditors. But the decision often ends up being made by the creditor who seems the closest to starting litigation.

DEBT MANAGEMENT TRICKS

Another area where professionals can help is in identifying abusive collection practices. It's common for

debt collectors to do things which are considered industry-standard tactics—but come close to fraud—in order to get borrowers to repay.

These tactics can include: 1) getting you to reveal information about yourself that you have no legal obligation to disclose; and 2) having you send money as a supposed settlement in full—but applying it only as a partial payment on account.

Keep in mind that the debt collection process is one long, **ongoing negotiation**. The first collection letters—often coming from a lender, before it brings in a collection agency—may include settlement offers that the lender considers high.

At this stage, the lender might offer a settlement of 75 or 80 cents per dollar owed. You can usually settle the account for less than that amount.

A normal credit card debt settlement case might take three to six months to resolve. If you want to go faster, you can settle in a few weeks. If you want to stretch things out, you can keep a negotiation going for a year or even 18 months. (But the lender will be reporting you as late the whole time.)

Why would someone want to stretch the credit card debt negotiation process out? Usually, to get more time to accumulate settlement money.

Are there any downsides to lengthening the credit card debt negotiation process?

- Interest accrues. Even you settle for 50 percent, interest building at 20 percent **on the total outstanding balance** still means a significant increase in what you will pay.

- At some point, you will want to begin rebuilding your credit. This process can't begin until all of the old credit card debts have all been settled.

- Laws, your own situation or creditor policies can change so that a credit card settlement—which might be doable now—will not be feasible in the future.

- The longer things go, the more likely the credit card company is to start litigation. If this happens, it (and sometimes other creditors) will usually refuse to participate in debt settlement talks.

If a credit card company sues you over an unpaid balance, it may be trying to accomplish one or more of the following outcomes:

- create a catalyst to speed up a formal workout plan;

- produce higher debt settlement figures for the creditor;

- win a judgment to formalize the amount owed; or

- win a judgment that allows a wage garnishment or other collection activity.

The credit card company *doesn't* want to force you to file bankruptcy. (They usually end up with much less—or nothing—if you do.) But that is a common result of their lawsuits.

DEBT SETTLEMENT TIMING

Most workout plans need to concluded in a one- to three-year timeframe. If you need more time than that, most creditors will begin lawsuits—which risk bankruptcy but allow the card company to pursue wage garnishment and other actions.

If your circumstances require you to stretch credit card settlement payments over five or six years to make a workout plan viable, you should consider:

- adjusting your budget,

- examining other options for dealing with your credit card debt, or

- contacting a bankruptcy lawyer.

Managing time is another thing that professionals can do well. Sometimes, a debt-management firm will put an account off to settle it in the future if it thinks more time or a change in account status will produce a better settlement. The knowledge of which card companies will wait—and which are more likely to sue—is often a debt-management firm's most valuable asset.

Keeping a cool head about settlement negotiations is hard for many people, when they are trying to settle their own accounts. The best debt-management firms can keep cool. One east coast debt-management professional said: "Sometimes the credit

card companies settle higher than the projected rate. Sometimes, lower. But they always settle."

This is the right attitude to take—whether you hire a debt-management firm or negotiate for yourself.

HANDLING COLLECTION CALLS

Another reason that people hire debt-management firms to help them set up workout plans is that the firms are supposed to handle all collection calls.

But, in truth, this doesn't work as often or as well as it's supposed to.

Sometimes the borrower will get a debt collection call by mistake; and, sometimes, the creditors will try to sneak around the debt-management firm. You are allowed to give a creditor the debt-management firm's name and contact information.

It's not a good idea to engage a creditor or its collector in any substantive conversation. If the creditor or debt collectors keep calling after you've told them to stop, they may be liable for damages under the Fair Debt Collection Act.

The number of calls a firm will take depends on the types of debt it's helping to manage. Some debt-management firms also work with medical bills, "under water" auto financing and other types of unsecured debt; other firms will only work with credit card debt. A few firms will combine unsecured debt

settlement services with services related to consolidating or refinancing student loans. But these are very different types of debt that involve very different styles of renegotiation. The most effective firms usually focus on one type of debt or another.

"DEBT SETTLEMENT" PROGRAMS

In most situations, formal debt settlement is a viable alternative to bankruptcy. Debt settlement (also known as debt negotiation) involves a personalized plan under which an individual or debt-management firm can negotiate a compromise to settle unsecured debts. Once the parties agree on a reduced balance, that will be considered payment in full.

Firms that organize formal "debt settlement" programs involving multiple accounts will require that you stop paying your creditors—and send your money each month to the firm, which deposits the funds into a trust or escrow account.

As we've noted, the most common non-secured debts are credit cards, medical bills, department store cards and balances left over from auto repossessions. Tax debts, alimony, child support, mortgages, car loans and federally insured student loans are usually excluded from settlement programs.

Caveat: No debt-management or settlement firm can guarantee absolutely that it can stop *all* collection calls from your creditors. A good firm can usually reduce a lot of the collection activity—but you're probably still going to get some calls.

Credit card companies won't simply write off large amounts of debt without at least *some* collection effort. Card companies are part of a multi-billion dollar industry that counts on people to struggle to make minimum payments. Making minimum card payments each month helps to make that possible.

HIRE A PRO OR DO IT YOURSELF?

You can negotiate your own settlements on credit card accounts. Still, service providers dominate this market because so many people don't *want* to do this kind of work themselves.

Here are some reasons to do it yourself—rather than hiring a debt-management firm:

1) Fees. When the credit card workout sector first started, the fee structure was on a performance basis—meaning that **commissions or fees were charged on the amount of savings** the company was successful in negotiating. This has changed. Fees not always tied to performance; and, increasingly, they are charged in advance.

Usually, the fees are prorated over the first year of the contract; but some companies take their fees over the first three or four months. Some companies also charge a start up fee and monthly service charges. This is money that cannot be used for settlement purposes.

2) A growing number of creditors refuse to work with debt-management companies. Their point is that the high fees should be better used to apply against any debt. For example, you owe $25,000 on five cards at $5,000 per card. Your up-front fee to a debt settlement company for professional services may cost you as much as $3,750.

Recently, both Bank of America and Citibank announced policies that prohibit working with debt-management companies. To get around this, some debt-management companies have their clients call on their own after a few training sessions.

3) Regulators and regulations are being forced on the debt-management industry by various government agencies: In 2004, the Federal Trade Commission shut down one of the country's largest debt settlement firms for charging millions of dollars in erroneous fees.

Futhermore, about a dozen states have either banned the use of or severely reduced the legal activities of debt-management firms.

4) Fees constantly go up. Debt-management firms know how unpredictable your financial situation can be, so they

charge fees in advance and increase them all the time. You might work within a program for a year, settle one or two accounts and then need to stop.

5) Debt-management companies often **claim they can dictate to the creditors** sizable discounts on your debt. **This is not true.** The companies work in the same arena as other debtors and have no influence on the collection or debt-reduction practices of large credit card companies.

6) Most debt settlement companies will set up your set aside money in "escrow accounts" that they control. Red flag items here: What is this escrow account? Do they give you a monthly statement on it?

Remember, debt-management companies are not banks; and, therefore, their escrow accounts are not FDIC-insured like most regular savings accounts. Funds sometimes disappear from these accounts...and tracking down the missing money can be difficult.

In short, credit card debt is easier to renegotiate than other kinds of debt. (Of course, that doesn't mean it's always *easy*.)

Most **credit card settlements follow fairly standard patterns**, which we've discussed in this chapter. If there's any category of personal debt that you

can use a starting point for developing or sharpening **your *own* financial renegotiating skills**, credit cards are it.

Even if you hire help in other areas or renegotiation, consider tackling this one yourself.

5

VEHICLES

Next to real estate, the asset that most people finance is an automobile, truck or other vehicle. And, because so many people finance cars, there are a lot of bad deals made and signed. Renegotiating a bad car financing is tough—through the early 2000s, it was practically impossible—but it can be done. More often, though, your best strategy for getting out of a bad car deal will be to live with it until its completion.

So, it's a good thing vehicle financing deals are relatively short—usually less than five years.

The bad thing is that they're getting longer—sometimes stretching out over seven or eight years.

In this chapter, we'll consider the standard forms of car financing and your best prospects for getting out of bad ones.

DEALERS WILL RENEGOTIATE

Car dealers use all kinds of tricks to "finesse" the terms of auto loan packages. Their standard strat-

egy is to do anything necessary to get you "into" the car—that is, to take possession of it. Once you're in the car, the dealer may try various tactics to renegotiate whatever deal you think you reached a day or week before.

On other words, car loans are renegotiation frequently...just not by consumers.

Among the shadiest of these dealer tactics:

- **yo-yo sales**, where the customer takes delivery on the spot—after agreeing to a deal but before final approval of the financing arrangements—and then the dealer calls back because of an alleged "problem" (especially likely if you're negotiating a "bad credit" auto loan);

- insisting that **additional insurance** products (usually sleazy "credit life" or "credit disability" policies that pay off the vehicle loan if you're hurt or you die) are necessary;

- insisting on a **larger cash down payment**—but keeping the loan's interest rate the same as if you'd made a smaller down payment (sometimes called a "cash boost" in industry jargon).

An example of the yo-yo tactic: A week ago, you bought a new car. The loan contract you signed included a four-year loan at 3.9 percent annual interest. You think that's a pretty good deal. You're still getting used to your new rig when, earlier today, the dealer called and said: "The 3.9 deal was

only available on another model. When can you come in to resolve this problem?"

Is this really a "problem" that you need to "resolve"? Maybe not.

In some situations, the dealer may claim that it couldn't sell the loan—when, in fact, it wants to renege on the sale for other reasons.

The main mechanism of this trick is the **Conditional Sale and Delivery agreement**, which dealers will sometimes include with the standard loan application paperwork. This addendum, which modifies the main contract, states that the dealer has a certain period of time (often seven or 14 days) to sell your loan to a bank or third-party finance company. If the dealer can't do this, it can either change the terms so that it *can* sell your loan...or demand the car back.

In this situation, you need to review your copy of the loan agreement. Does this paperwork mention anything about the sale being "subject to financing" or use similar language? Often, this "subject to financing" verbiage will appear in the section of the contract headed "**Other Terms and Conditions**" or "Miscellaneous." However, some lenders will place the language in other parts of the contract, so you need to read the whole thing.

If your contract does include "subject to financing" language, you're in a jam. Your best option will be

contact other lenders (often an online search will be fastest) and try to work out another loan—similar to the one you were *supposed* to get from the dealer in the first place.

Otherwise, your best option may be to return the vehicle to the dealership.

You will usually have the right to return the car rather than renegotiate the loan. And, in most situations, it's in your interest to let the dealer have the car back. But be wary of threats (coming from the dealer) that such a deal will show up on your credit as a vehicle repossession. Usually, this isn't so.

In order to exercise the "subject to financing" clause, the dealer will—usually—have to nullify the entire agreement. So, you shouldn't face any additional charges (and you may be owed a refund of your down payment).

If the "subject to financing" language isn't in the contract, you don't have to "resolve" anything. You don't have to "help out" the dealer.

If the dealer keeps calling or gets threatening, insist that he show you the "subject to financing" language in the contract. Frankly, if the dealer put you into the vehicle without "subject to financing" language in the documents, he made a mistake. Then, he's in the position of either holding the loan or finding a lending institution that will buy it

out—essentially, he's in the same position that you would be if the language is in the contract.

Whenever someone from a car dealership calls you about "resolving a problem" after you've taken possession of a vehicle, insist on speaking to the sales or finance manager—don't negotiate with a sales person, sales assistant or "marketing" staffer. These people are not, generally, in a position to speak with any authority about your deal.

Another tip: If the car dealer calls you back because of a financing problem, ask for the name, telephone number and address of the lending institution that rejected the loan application. And the name of someone you can talk to there. If your application has actually been rejected, you have the right to **speak directly to the finance company** about it.

REFINANCING A VEHICLE LOAN

Refinancing a car loan—in the manner that you might refinance a house—is not an easy thing to do. Generally, your existing lender will not consider a refi.

The reason that car loans are hard to renegotiate is that **cars lose value so quickly**. Unlike real estate—which, except during recessions, tends to hold or increase in value—cars lose their value quickly and predictably. **An asset with a falling value is a hard thing to refinance.** In other words, the terms

of the loans are usually short enough and the amounts in question small enough that refinancing doesn't make economic sense.

Some specialty lenders will refinance loans that other companies originate. They'll loan up to the balance of your existing loan (there's no such thing as a "cash out" car refi). These refi's are, as you might expect, **effectively used-car loans**; the thing to watch for in them are the high interest rates. Some specialty auto lenders charge rates as high as 20 percent per year (as opposed to standard new cars loans that average around 6 percent).

Why would anyone refi an existing car loan at 6 or 8 percent for a loan with a much higher interest rate? **To bring the monthly payment down.** The used-car lender may be willing to extend your existing two or three years of payments over six, seven or eight years. In some cases, this may make your monthly payment lower—but not by enough to make the deal worth taking.

The most important factors used to renegotiate a vehicle loan are:

- remaining loan amount,

- repayment period or amortization (a longer period reduces the payments but may increase the overall interest paid),

- interest rate and due or adjustment dates.

Sometimes, car loans are negotiated with additional **personal guarantees** and the amount of your ability to pay the new loan payments needs to be below

what you were able to do when the loan started but not lower than you show an ability to pay the new lower payment.

When you refinance a car, your rate probably will not go down. That's because you are taking out a loan on a car that is older than it was under the first loan—in other words, **it's a used-car loan**.

BEWARE OF USED CAR DEALERS

Some used car lots take advantage of buyers—and especially buyers with poor credit. The dealers will lock the buyers into high-interest-rate loans that go on as long as standard new car loans (reasonable used car loans should have shorter terms).

Sometimes, the buyer will realize—several months or even a year later—that the deal is bad, the loan is too expensive and she could have done better. She'll want to get of the deal. But this may not be in her best financial interest. The hard truth is that the best way to get out of a bad car deal is to pay it off.

> **If you're underwater on a car and having trouble making the payments, selling the vehicle usually won't help. You'll owe the lender money after the sale (and so you may not be able to complete the sale—especially if the lender has a lien on the title).**

In some cases, new or used car dealers that are desperate to close sales will accept cars with negative equity as trade-ins. They'll pay off the note, sell the

car and then add the shortfall on to the amount you owe on the new vehicle. **This is a very bad idea.** It increases your debt and schedules it over a longer period...often at a high interest rate. And with strict limits on prepayment or refinancing. These are all things to be avoided in a car loan.

Beware of used car dealers who are eager to lend you money to buy a car. In many cases, used car dealers make more money from the high interest and harsh terms of their loans than the make from buying and selling vehicles.

And some used car dealers will try other sleazy tricks:

- combining existing loans that you have (on other vehicles or even on things like credit cards) into one loan with a higher interest rate;

- forcing you to find a cosigner—and then charging both of you a higher interest rate than you would get from a conventional lender.

Buying a used car is often the best deal, in terms of value for your automotive dollar. Personal finance gurus like Dave Ramsey and Robert Kiyosaki recommend it. More importantly, frugal billionaires like Sam Walton often stick with used cars—even though they could buy the fanciest rigs around. But the key to realizing the value in used cars is to **avoid borrowing money to buy them.**

Again, loans on cars are a bad idea because cars are always losing their value. The best advice for doing well on a car purchase is to save money and **buy the best used car you can afford for cash**.

DEALING WITH CAR LEASES

Since the 1980s, leases have become a major part of how Americans finance vehicles. This isn't a good thing. By design, leases obscure the real cost of driving a particular car. So it's no surprise that people often end up trying to renegotiate.

First, some background. There are two main kinds of auto leases—closed-end and open-end:

- With a **closed-end lease**, you return the vehicle at the end of the term and "walk away." Sort of. You're still going to be responsible for certain end-of-lease charges—like excess mileage, wear and tear, and loosely-defined "disposition" (essentially, the lease company's transaction costs related to reselling the rig). Also, you usually have an option to purchase the car for a predetermined price at the end of the term. This price—called the "residual value"—is a critical element of any car lease.

- An **open-end lease** is usually limited to commercial contracts. Under this type of agreement, the market value of the car is determined at the end of the contract term. This is compared to the residual value of the vehicle and the per-

son (or company) that leased the vehicle pays the difference.

One important point: You do not lease a vehicle from a dealership, even if the credit manager there arranges the deal for you—you lease it from a finance company. The dealership sells "your" car to the leasing company, which then leases it to you under the terms agreed upon between you and the credit manager.

To be frank, **most auto leases are bad deals**. From the car company's perspective, the purpose of leases is to "sell" people more expensive vehicles than they can really afford. The main way that they accomplish this is by obscuring the residual, "buy out" or "back end" payments due at the end of the agreement. So, any agreement that modifies or allows the consumer to exit the lease isn't likely to be beneficial to that consumer.

> **If you return the vehicle during the lease term, you're still liable for the back-end payment (among others). That payment is usually going to be the main thing the leasing company cares about.**

The following are some of the key definitions in any vehicle lease:

- **capitalized cost**: the port of the purchase price that's being financed;

- **depreciation**: the rate at which the financed car loses value;

- **gap insurance**: financial protection against an usual decline in the value of a leased vehicle

- interest rate (sometimes defined as "money factor"):

- monthly payment

- **residual**: a predetermine repurchase price of the vehicle at the end of the lease

- term of lease: the length of time the contract is in effect

These terms fit together to determine **how much a lease *really* costs**. When leasing a car, you're paying for the depreciation of that asset while you use it—plus interest. The depreciation is calculated as the difference between the capitalized cost and the residual value.

How does this affect a renegotiation? While the depreciation is paid off evenly over the lease term, **the depreciation of a car is not linear**. The difference in the *actual* depreciation and the *paid* depreciation is known as the gap amount—something you'll have to pay if you terminate the lease early.

To understand whether a specific lease is either a good deal or bad one (and, to repeat for emphasis, most tend to be bad), you need to crunch a few numbers:

1) Figure out the monthly depreciation of the vehicle. To get this, subtract the residual value of the vehicle from the capitalized cost. Take the difference and

divide it by the number of months you plan to lease the car—the result is the monthly depreciation.

2) Calculate the monthly finance charge. Add the residual value and the cap cost, then multiply that by the money factor. This results in the monthly finance charge.

3) Add the monthly depreciation and the monthly finance charge, and you have calculated your monthly payment.

Some of these numbers are more important than the others to someone who wants to get out of a lease. For example, while many people focus on the monthly payment they need to maintain a lease, that's really not so important when calculating the cost of **terminating the contract**.

As the person in possession of the vehicle, you should be looking at two things:

1) the back-end payment due on the vehicle when then lease ends; and

2) the current value of the vehicle on the used-car market.

Said another way: The easiest lease to escape is one with a low money factor and a high residual value.

Here are a few examples of dirty tricks that some car dealers employ with regard to leases:

- The Money Factor/APR Switch. This may seem like an obvious trick, but it works for crooked dealers more often than you'd expect. The money factor and the APR can both be expressed as decimals—but they are not inter-changeable. If you're not careful to see this trick, the difference in the decimals can cost you thousands of dollars.

- Bogus Call-Back. A dealer will phone you about a month after you've signed the lease and claim there's a minor error in your contract that will add $5 or $6 a month to your payment. He'll ask you to come back to the dealership and sign a "corrected" contract. When you get there, they changes will add $13 or $14 to your payment—or the dealer may have bigger changes, like extending the term of the lease. In other words, the "minor error" is an attempt to renegotiate the lease.

Generally, a finance company has no right to re-scind an existing lease, unless you are delinquent on payments.

- The Undisclosed Acquisition Fee. An acquisition fee is required by most leasing companies in order to open a lease. This fee, also known as a lease origination fee, is usually around $450, but can be as high as $700. Originally, this

fee was invented by the dealers, who would claim the car leasing company charged the fee—the dealer would then pocket the fee. But the leasing companies caught on and began actually charging the acquisition fee.

Dealers are often trained to hide the acquisition fee in the fine print of a contract. To avoid this, make sure that every cost item in your lease agreement is itemized. And double check these items.

- The Bogus Trade-In. Some dealerships will claim to be able to "trade-in" your lease. What the dealer will do is carry over all the penalties and fees from the early termination onto the new lease. You'll pay them, eventually—and with interest. To avoid these expenses, don't "trade in" your leased car.

WAYS OF ESCAPE

Most vehicle leases come with some sort of standard early termination formula—essentially, a way to calculate the gap amount and charge you a fee equal to that if you want to escape the contract.

As you might guess, these **fees are extremely high during the first few years** of the lease term.

A caveat: Some dealers will insert their own language and formulas for calculating early lease termination—if they think you have money and a short attention span. And, in a few cases, a dealer will conspire with a leasing company to raise a termination fee above even what's written in the lease contract. There are lots of games played with these deals. Be sure to read the details of your contract's early termination fees.

An increasingly popular way to exit a lease is to find someone willing and able to assume the payments. Internet Web sites like LeaseTrader.com are designed to match people who want out of their leases with people looking to get a good deal on a vehicle by **assuming an existing lease**. These lease assumptions can be difficult and time-consuming, though, because the leasing company will usually need to approve the transaction. This means it want to review the credit and finances of the person assuming the lease—and it may charge you and/or that person for the privilege.

Reread your lease agreement to see whether it allows transfers. If it's not flat-out banned, check to see if complete transfers are permitted.

Some companies let you transfer your lease to others, but keep your name on the contact as its guarantor. If the person who buys your lease stops mak-

ing payments, the responsibility for those payments falls back on you.

Keep in mind that lease trading also costs you listing charges, lease-transfer fees and vehicle inspection fees.

In some situations, selling the car—even if you're leasing it—in a private transaction will be the best way to minimize your exit costs. But, in this situation, you'll need to find a buyer who's patient and willing to work with you while you use his or her money to get a title release on the vehicle.

If the current used-car value of the vehicle is equal to or greater than the residual value in the lease, you may be able to find some sort of finance deal to get out of the lease.

> A caveat: leasing companies are very good at assessing the market value of cars when they set residual values on leases. The chances are great that the residual value of a car you're leasing will be higher than the current market value—limiting your exit options and effectively locking you into the car.

But, if the residual and current market value are close, you do have some choices. The best choice is usually to convert the financing package from a lease to a conventional (used) car loan. If the car has held its value and interest rates have gone down since you started the lease, you should be able to find a decent **conversion loan**.

What about "**just walking away**" from a car you can't afford any more—like people who walk away from houses that they can afford and are underwater? The short answer: The costs of walking away from either are very high.

Since the money and time related to a home loan are relatively large, escaping them may be worth the costs—in terms of court judgments and/or credit score damage. Since the dollars and time related to vehicle financing are smaller, walking away doesn't usually make as much sense.

Of course, you can drop the car off at the dealer—or *any* authorized dealer—and the process will be the same:

- the finance company will legally repossess (a "voluntary repo") the car while it sits on the lot;

- the dealer holding the car will have "first dibs" on buying it from the finance company at a wholesale price;

- if the dealer doesn't want to buy the car, it will send the car to a wholesale auction agency;

- after the car has been sold at auction, the finance company will compare the residual value to the sale price and bill you for the difference;

- if you don't pay the finance company the difference, it will retain a collection agency to pursue you; and

- regardless of whether there's a difference or you pay it, your credit will be shot.

Remember: To cut a contract short, you'll usually have to pay all the remaining lease payments, plus a termination fee and a lease-disposition fee, which is typically collected when the vehicle is not purchased at the end of the lease.

The leasing company can also drive up the costs by charging you for wear and tear on the car. In the end, you may spend more than the car is worth to end the lease early.

RENEGOTIATING A CAR LEASE

A better option, though it will take more work, is to renegotiate the lease.

The first step in this process should be familiar by now: Call the leasing company, explain your situation and ask to extend the contract's term—which should lower your monthly payment. This will cost you more money in the end, but allows you to avoid defaulting on the contract.

> **The leasing company also may let you skip a couple of payments and move them to the end of the contract term. This gives you a break without adjusting the monthly payment.**

Some leasing companies are more flexible than others on renegotiating the terms of a contract. (As a

rule, the finance companies owned by the major car manufacturers are less willing to renegotiate than leasing companies affiliated with banks.)

Another common point that consumers renegotiate on vehicle leases: The **mileage allowance**. Generally, you can add extra mileage to your lease in the first third of the contract term—as long as you have a standard mileage lease and not a "low mile" contract. You buy the extra miles at a "per mile" price, which raises your remaining payments.

> When you "buy" extra miles for a lease, all you are really doing is taking money off the end residual value and redistributing that money into your monthly payments.

If you buy $1,000 worth of extra miles in a 36-month lease, your end-of-lease buyout price will drop by $1,000—and your monthly payment will go up by about $30.

If you plan to buy the vehicle at the end of the lease, it doesn't make as much sense to buy extra mile. Buying more miles during the lease term will **lower the residual price** and, therefore, the purchase price; but there is usually room to negotiate that purchase price—whether or not you've paid for extra miles.

The mileage allowance is most important if you plan to drop the vehicle off at the end of the contract. Then, if you haven't paid for the miles through

monthly payments, you'll have to pay a lump sum—which is usually higher than if you had purchased the additional miles up front.

> Mile overage fees can be very high: over $10,000 on a $40,000 (when new) vehicle is not unheard of. This is a major reason not to lease a vehicle. But, if you're using more miles than your contract allows, make an adjustment as soon as possible.

With some leasing companies, if you purchase extra miles on your lease and do not use them, the value of the unused miles can be "refunded" at the end of the lease. Ask about this **refundability**.

Sometimes, a leasing company will forgive part of a mile overage if you **lease another vehicle** with it at the end of your current lease.

If you try this negotiation, make sure that the leasing company actually *forgives* the overage; in some cases, a company may say that it will forgive the extra miles—and then add the overage fee into the next lease.

Some people claim to knowingly drive over a lease's allowed miles with the plan to "work something out" when the time comes to hand the car back. This kind of "planning" really just limits your options (though there *is* some room for deals to be made near the end of a lease).

As a consumer, your point of greatest negotiating leverage comes within 90 days of the end of your lease term. This is the time to calculate your mileage, review the vehicle's residual value and—if you're so inclined—make a deal to buy or return the car.

The leasing company will be open to making a deal if you're close to the end of the lease but haven't yet returned the vehicle. If the leasing company knows a few months ahead of time that it doesn't need to process the returned vehicle, it can save inspection costs and various processing fees. These savings usually give it some room to sell you the car at less than the residual value defined by the contract.

If you're thinking about buying the vehicle at the end of the lease, you'll need to compare the residual value with the leasing company's definition of "fair market value" (FMV) and the actual market value of the vehicle. These three values are not always as close to one another as they should be. For example, one car dealer told us:

> ...FMV *is almost always less then the customer's buyout {residual}. And we don't take cars very often because the finance company's FMV is almost always a bit too high.*

Here, you get some idea of how leasing companies use these different values. The residual is higher than the contractual FMV—which is, itself, usually higher than actual market price. So, the leasing company uses the residual as a kind of buffer against the lower actual value of the vehicle.

For this reason, finance companies don't have much incentive to negotiate residuals. But, if the car is a good one, it's usually worth a call at 60 to 90 days before termination to ask about a deal to buy the car. The same car dealer said:

> ...you can negotiate anything. Even if the contract's definition of FMV is high, it is a vehicle that you know the history of. If you've taken good care of it, it should in better shape than most used cars.

Most leasing companies are insured against over-valued residuals—but the insurance only kicks in after the companies take back possession of vehicles and resell them at wholesale. This is one more reason that offering to save them the hassle of dealing with a returned car can be a good negotiating point.

In these negotiations—as with others—don't take the first answer as gospel. According to one auto finance company staffer:

> I had a friend who was about a month out from returning his E-class Mercedes after a three-year lease when he got a phone call. Mercedes USA asked him if he wanted to purchase the car and, after hearing the residual value, he told them that he'd be returning it. They called back a little later and offered him a great price if he'd be willing to buy it. He loved that car and agreed to it.

UNDERWATER. UPSIDE DOWN

In most situations, for the first several years of a car loan or lease, you will owe more on the vehicle than it's worth. Car companies and finance companies

Loans, Direct Unsubsidized Consolida-
tion Loans, and Federal Unsubsidized
Stafford Loans, Federal PLUS Loans, and
Federal Unsubsidized Consolidation
Loans. These loans are also issued by
Sallie Mae, Citibank, Wells Fargo, etc.

It's a common misperception that Sallie Mae loans
are subsidized and student loans from standard
banks are not.

**The company issuing a student loan doesn't deter-
mine what kind of loan is issued; a Sallie Mae loan
may be unsubsidized (or "private") and a loan from
your local bank may be subsidized.**

Another common misperception: Some people
think that defaulting on a student loan is less dam-
aging than other kinds of default. **This isn't so.** If
you default, the entire unpaid balance and collec-
tion fees related to your loan (or loans) **become due
immediately**. Failure to repay a student loan can
result in:

- loss of federal income tax refunds due
 to you;

- legal action against you;

- collection charges (including attorney
 fees) being assessed against you;

- loss of eligibility for other federal stu-
 dent aid;

- loss of eligibility for loan deferments;

- negative credit reports to major credit bureaus;

- your employer withholding part of your wages to give the lender (wage garnishment).

An important point to keep in mind: Private student loan companies can use **the same collection practices** that government agency lenders use. This is a significant difference from other types of high-interest consumer debt. A bank that loaned you $10,000 or $50,000 at 20 percent a year to go to school can use the powers of the federal government to track you down and garnish your wages.

Proceed very carefully with these things.

RENEGOTIATING STUDENT LOANS

When managing student loans, the first thing you need to establish is the status of the loans. With other kinds of consumer debt, status is usually current, delinquent or default. Student loans have more options; an account (which may be several individual loans combined) may be:

- discharged,

- in default,

- in deferment,

- in forbearance,

- in grace period,

- in military/deferred,

- in school/deferred,

- paid in full,

- repayment-current,

- repayment-delinquent, and

- suspended.

Your first concern should be in making sure that **your loan isn't in default**, usually defined as not having made a payment or attempting to renegotiate payments for the past 180 days.

According to the U.S. Department of Education:

> *Default occurs when a Direct Loan borrower becomes 270 days delinquent in making payments on their loan(s). The consequences of default can be severe.*

If you're in default, your lender is very unlikely to renegotiate your loan. But you can ask your lender to establish a "reasonable" repayment schedule, based on info you supply such as monthly income, other debts, dependents and so forth. After you've made payments as agreed for six months, you may then be eligible for a new loan.

The Department of Education's Direct Consolidation Loan Program offers various repayment plans. Among the most common:

- **Consolidated Standard Repayment Plan**—Under this plan, you make fixed monthly payments of at least $50 and repay your loans in-full within 10 to 30 years from the date repayment started, depending on the total amount you owe. The payments may be adjusted

annually to reflect changes in the interest rate.

- **Consolidated Graduated Repayment Plan**—Under this plan, your payments are lower at first and increase every two years. Your minimum payment will be at least equal to the amount of interest accrued monthly. You will repay my loan in 10 to 30 years, depending on the amount you owe. The payments may be adjusted annually to reflect changes in the interest rate.

- **Extended Fixed Repayment Plan**—Under this plan, you make fixed monthly payments of at least $50 and repay the loan in-full within 25 years from the date repayment started. The payments may be adjusted annually to reflect changes in the interest rate. In order to qualify for this plan, your total education loan indebtedness must be at least $30,000 and you must be a "new borrower" (defined as someone who had no principal or interest balance on a Direct Loan as of October 1998 or on the date the Direct Loan was obtained after October 1998).

- **Extended Graduated Repayment Plan**—Under this plan, your payments are lower at first and increase every two years. Your minimum payment will be at least $50 or the amount of interest accrued monthly, whichever is greater, for a maximum of 25 years. The amount

of the payments may be adjusted annually to reflect changes in the interest rate. To qualify for this plan, your total education loan indebtedness must be at least $30,000 and you must be a "new borrower."

- **Income Contingent Repayment (ICR) Plan**—This plan bases your monthly payment on your yearly income, family size and loan amount. As your income rises or falls, so do your payments. After 25 years, any remaining balance on the loan will be forgiven (you may have to pay taxes on the amount forgiven). Each year your monthly payment will be based on your family size, annual Adjusted Gross Income (AGI) as reported on your federal tax return, and the total amount of your Direct Loans. To participate in the ICR Plan, you must authorize the Internal Revenue Service to inform the Department of Education of the amount of your income. This information will be used to calculate your repayment amount, which will be adjusted annually to reflect changes in your AGI.

There's a lot of paperwork required to qualify for any of these plans—especially for the ICR Plan. It must be executed accurately and completely. The Department of Education will not place you on the ICR Plan until it has received your *completed* forms.

Eligibility for these repayment plans may vary by loan type, loan balance, and disbursement date.

As with other types of loan, you can **lower your monthly payment by lengthening your loan repayment schedule**—but this will make the overall cost higher. (And not all private loan programs are eligible for extended repayment.)

Note: Most private student loans first disbursed June 1, 2009 and later require immediate monthly payments of interest only. Check the terms of your loan's Promissory Note to see whether your loan status shows repayment.

Late charges: If you fail to make any part of an installment payment within 30 days after it becomes due, you may owe a late charge. For subsidized loans, this charge may not exceed six cents for each dollar of each late installment. However, private lenders can (and usually do) charge more.

CANCELING YOUR LOAN

Some student loan programs allow for all or part of the total loan principal and accrued interest to be canceled in certain circumstances. A canceled loan may also be referred to as a "discharged loan."

You may be able to request that your lender cancel your student loan entirely if you:

- are permanently or temporarily totally disabled;
- are in the military full time;

- are teaching in a poor area or to needy students;

- are providing medical care in a poor area or to the needy;

- are providing certain types of community service, such as serving in the Peace Corps;

- are working in law enforcement (this applies to certain loans only);

- withdrew from school or the school closed before you could complete your degree and you didn't receive a refund.

FORBEARANCE

Some student loan companies work with borrowers to renegotiate their loan terms to cut down on the number of defaults; others take a harder line.

Another option for borrowers with federal student loans—which relies less on the whoms of the lender—is **forbearance**, which allows them to temporarily postpone or reduce payments.

Examples of financial hardship that may qualify for forbearance include:

- illness;

- service in a medical or dental internship or residency program that meets certain criteria;

- service in a national service position for which you receive a national service

education award under the National and Community Service Trust Act;

- periods of time when my monthly debt burden for all federal Title IV student loans equals or exceeds 20 percent of my total monthly gross income (for up to three years).

Forbearance isn't a permanent solution. It's a specified period of time during which your loan payments are temporarily suspended or reduced. During a forbearance period, you will receive quarterly interest statements and have the option to pay the accrued interest. If you don't, any unpaid accrued interest will be capitalized.

In short, forbearance lets you suspend or reduce your student loan payments under certain circumstances and for specified periods of up to one year.

> **In most situations, it's easier to get a forbearance than a deferment. Forbearance can help you avoid delinquency and default if you're facing temporary financial difficulty.**

The lender will usually require some form of declaration or statement from you that you intend to repay the loan(s).

Forbearance may also be the first step in another resolution of a student loan account. In many cases, the Department of Education grants forbearance for up to 60 days to allow a borrower to collect and

process documentation supporting his request for a deferment, forbearance, change in repayment plan, or consolidation.

Sometimes a forbearance can be used to eliminate a delinquency that persists, even though the borrower is making scheduled installment payments.

DEFERMENT

If you aren't in default, you may be able to get your student loans deferred. Under this arrangement, you make no payments for a specific period of time. You may qualify for deferment, if you:

- are permanently or temporarily totally disabled;

- are "conscientiously seeking, but unable to find, full-time employment;"

- are engaged in "a full-time rehabilitation training program for individuals with disabilities;"

- have a federal loan and can prove that you are suffering an economic hardship (as defined by the lender);

- are enrolled in school at least half-time;

- are in the military (or Peace Corps) on a full-time basis; or

- are providing medical care in an economically-disadvantaged area.

The unemployment and financial hardship deferments last a maximum of three years. The others can last longer.

In some situations (depending on the language of each loan), **interest will accrue** during the deferment; in others, it will be **suspended**. Generally, interest doesn't accrue on subsidized loans during deferment; but it *does* accrue to unsubsidized loans. Accrued interest will be added to the principal balance of the loans at the end of the deferment period. This will increase the amount you owe.

Deferment is limited to specified time frames—but it **lasts longer than forbearance**. If you've already had one deferment, you may be eligible for the same type again. In other cases, you may have exceeded the time limit on a particular deferment and may no longer be eligible to apply for that same type.

If you're in default on any of your loans, you are not eligible for a deferment. If you have consolidated your loans jointly with your spouse (not, generally, a good idea), you must both meet deferment eligibility criteria at the same time in order to qualify.

Lenders don't offer deferments spontaneously. You have to ask for them—and you'll have to provide paperwork that shows you're qualified. For example, here's what the Department of Education says (in its slightly creepy first-person style) about an "in-school" deferment:

> *The Direct Loan Servicing Center will process an in-school deferment based on (i) my request with document showing I am eligible, (ii) the Direct Loan Servicing Center's receipt of information from*

> *my school about my eligibility in connection with a new loan, or (iii) the Direct Loan Servicing Center's receipt of student status information indicating that I am enrolled on at least a half-time basis.*

If you have a balance on an **FFEL** Program loan that was made prior to July 1, 1993 (back then these loans were known as Guaranteed Students Loans or GSLs), additional deferments may be available. These include deferments while you are:

- unable to secure employment because you're required to care for a spouse or dependent who is temporarily totally disabled (for up to three years);

- serving as a full-time paid volunteer for a tax-exempt organization or an AC-TION program (for up to three years);

- teaching in a designated teacher shortage area (for up to three years);

- on parental leave (for up to six months);

- a working mother entering or reentering the work force (for up to one year).

STUDENT LOAN CONSOLIDATION

The best form of student loan renegotiation is the so-called "loan consolidation" which, in truth, is a kind of cramdown refi of existing student loans.

According to Sallie Mae's Web site (at http://www.salliemae.com):

Severe legislative cuts made by Congress made federal student loan consolidation uneconomical. This, combined with the credit market deterioration, has caused us to suspend participation in the federal consolidation loan program.

> Some borrowers may qualify for student loan consolidation, which combines multiple student loans into one consolidation loan with one lower monthly payment. Just keep in mind that federal and private student loans can't be consolidated in the same loan.

Eligible Loans: The following federal education loans are eligible for consolidation into a Direct Consolidation Loan:

2a. The following subsidized loans will be consolidated under one loan identification number:

- Subsidized Federal Stafford Loans

- Guaranteed Student Loans (GSL)

- Federal Insured Student Loans (FISL)

- Federal Direct Stafford/Ford Loans

- Federal Direct Subsidized Consolidation Loans

- Federal Perkins Loans

- National Direct Student Loans (NDSL)

- National Defense Student Loans

- Subsidized Federal Consolidation Loans

2b. The following unsubsidized loans will be consolidated under one loan identification number:

- Unsubsidized Federal Stafford Loans (including Non-Subsidized Stafford Loans made prior to 10/1/92)

- Federal Supplemental Loans for Students (SLS)

- Unsubsidized Federal Consolidation Loans

- Federal Direct Unsubsidized Consolidation Loans

- Federal Direct Unsubsidized Stafford/ Ford Loans

- Auxiliary Loans to Assist Students (ALAS)

- Health Professions Student Loans (HPSL)

- Health Education Assistance Loans (HEAL)

- Nursing Student Loans (NSL)

- Loans for Disadvantaged Students (LDS)

2c. The following parent PLUS loans (unsubsidized) will be consolidated under one loan identification number:

- Federal PLUS Loans

- Parent Loans for Undergraduate Students (PLUS)

- Federal Direct PLUS Loans

- Federal Direct PLUS Consolidation Loans

To qualify for a Direct Consolidation Loan, borrowers must have at least one Direct Loan or Federal Family Education Loan (FFEL) that is in grace, repayment, deferment or default status. Loans that are in an in-school status cannot be included in a Direct Consolidation Loan.

Borrowers can consolidate most defaulted education loans, if they make satisfactory repayment arrangements with the current loan holders or agree to repay their new Direct Consolidation Loan under the Income Contingent Repayment Plan.

There are two main benefits to student loan consolidation:

1) The bigger benefit is reducing interest rates, and therefore monthly payments and overall debt. Interest rates are near record lows now, so chances are you'll get a better rate now than when you first got your loan.

2) The second advantage is reducing the number of creditors. This makes it easier to keep track of your payments. More importantly, it means you only have to deal with one creditor if you're late with a payment or need to renegotiate your loan for some reason.

The interest rate on your Direct Consolidation Loan will be based on the weighted average of the inter-

est rates on the loans being consolidated, rounded to the nearest higher one-eighth of one percent, but shall not exceed 8.25 percent. This is a fixed interest rate, which means that the rate remains the same throughout the loan.

> **You may be able to consolidate all your student loans together at a renegotiated rate. You'll probably end up paying more interest if your loan period is extended, but it's possible you'll qualify for a lower interest rate to balance it out.**

Most consolidation lenders **won't consolidate student loans that total less than $7,500.** If you go with a consolidation loan, you'll want to make sure you can accelerate payments without a penalty, if your financial situation improves over time.

Some important questions to ask before consolidating student loans:

1) How much are you willing to pay over the long term? Like a home mortgage or a car loan, extending the years of repayment increases the total amount you have to repay.

2) How many payments do you have left on your loans? If you are close to paying off your student loans, it may not be worth the effort to consolidate or extend your payments.

PRIVATE STUDENT LENDERS

Private student loan lenders will generally not re-negotiate the terms of the loan. They can be hell to deal with, because there is **no requirement for them to offer alternative payment plans** or to offer deferments or forbearances.

Here are some common questions that stunned graduates ask about private student loans:

> *How can private lenders get away with $300K finance charges for helping someone go to school?*

Unfortunately, those were the terms you sign for and $75,000 is a small mortgage. They can "get away" with it because they are private loans, not governed by the federal system. And unless you want a judgment and 25 percent of your wages garnished for the rest of your working life, increasing your income is the only reality with private loans!

> *Aren't some private loans guaranteed by the government? And if so, when the government takes them over, can't you work out something then? If they're not guaranteed, then isn't it just one big unsecured loan?*

> *I thought the only reason you couldn't file bankruptcy on most student loans was because they were backed by the government. But, if they're not backed by the government, why can't you file?*

Private loans do allow deferral while you are in school but, from that point on, they are just like normal consumer loans.

- interest rates based on credit score and can be very high,

- may require a co-signer,

- interest starts accruing day one,

- no or limited forbearance privileges,

- no or limited hardship or reduced payment options.

Since these loans are outside the federal system, they cannot use tools like wage garnishment—as with federal loans. The *do* actively sue and take out judgments—and students find themselves being garnished at the standard 25 percent rate.

Private loans are also not dischargeable in bankruptcy anymore. Like federal loans, hardship discharge is possible but extremely rare as most borrowers fail the required tests.

Some examples of private student loan repayment options are:

- Interest-only repayment: Payments of interest only for a specified period of time followed by payments of principal and interest for the remaining repayment term.

- Extended repayment: Lower your monthly payment by extending your repayment term. Minimum cumulative outstanding loan balance by private

student loan program requirements apply. Extending the term may result in higher overall cost.

Eligibility for these repayment plans may vary by loan type, loan balance and disbursement date.

To reduce your costs, make payments on the interest—even if it isn't required. (Some private loans require interest payments while you are in school.)

LENDER TRICKS

One of the most important things to keep in mind when dealing with a student loan company— whether you are negotiating a consolidation, forbearance or anything else—is to make sure the company doesn't play tricks with how the accounts are reported to credit bureaus.

In May 2008, Sallie Mae faced allegations that it had misled borrowers about how their payments were being reported. The complaints were related especially to renegotiated terms: When borrowers began making their payments in full accord with the new arrangements, Sallie Mae reported to credit bureaus (including the "Big Three"—Experian, Equifax and TransUnion) that the accounts were in "partial payment" mode. These reports triggered so-called "warning flags" on borrower's credit reports and impaired credit ratings.

One borrower reported a 50-point drop in her FICO score. Sallie Mae told the credit bureaus that her

student loan account was past due—despite the fact that she had paperwork proving that she'd renegotiated her payment schedule…with Sallie Mae.

Several other borrowers reported the same problem.

When one affected borrower called Sallie Mae to complain, a representative said that Sallie Mae had initiated a new reporting procedure in order to "increase its posting of losses." The rep told the borrower that, if she increased her monthly payment amount by $31, Sallie Mae would contact the credit bureaus and withdraw the "partial payment" flag. This was a renegotiation of the renegotiation—that seemed a little like extortion.

In the 1980s and early 1990s, lenders paid slight attention to student loans. But, in the late 1990s, that changed. Student loans are more important to people's credit scores than they used to be. If a student loan account is reported as delinquent or in partial payment, your ability to get a car loan or mortgage can be damaged.

STUDENT LOANS & BANKRUPTCY

Are you falling behind on your student loan payments and worried that the Department of Education will take your tax refund, garnish your wages or sue you? If so, you need to look for ways to earn out of the trouble—because bankruptcy (usually) won't eliminate your student loans.

> The key point here: The several bankruptcy "reform" bills that were passed into law in the early and mid-2000s limited a borrower's ability to discharge student loans—even "private" or unsubsidized loans.

Still, there are some remedies available in bankruptcy (especially a Chapter 13 "reorganization" filing) that may help.

In a Chapter 13 bankruptcy, student loans will usually receive a *pro rata* payment—along with other unsecured creditors—during the life of the plan. However, after the plan ends and the unsecured debts are erased, the student loans will still be in force. And the lenders can begin collection activities again when you come out of the plan.

Also, bankruptcy judges have some leeway in handling student loans. Bankruptcy code allows judges to apply an "undue hardship" standard to certain debts—including student loans. Most judges follow a three-part analysis when considering this:

1) the terms of the loan must represent a *severe* financial hardship, so as to violate the "fresh start" spirit of the bankruptcy process;

2) the education the loan represents must be of no present value to the debtor; and

3) it must be likely that the education will never be of future value to the debtor.

So, if you work in human resources but you're plagued financially by $150,000 in private student loans at 22 percent a year from the studio art degree that you got nearly a decade ago, you might have a case for undue hardship.

> A caveat: The undue hardship review won't happen automatically. You or your bankruptcy lawyer will have to file a specific request to the court to consider the student loans an undue hardship.

SOME IMPORTANT DEFINITIONS

Like most financial products, student loans have a jargon of their own. In this case, terms and definitions used by the U.S. Department of Education are used extensively—even by lenders that aren't affiliated with the government.

Here are some of important terms and definitions related to student loans:

Direct PLUS Loans: Unsubsidized loans available to parents of dependent students, and to students enrolled in graduate or professional programs. These loans are available regardless of financial need and the amount of eligibility depends on the total cost of education.

Federal Family Education Loan Program (FFEL Program): A Federal program authorized under Title IV of the Higher Education Act that provides loans to eligible student and parent borrowers. The pro-

gram consists of Subsidized and Unsubsidized Federal Stafford Loans, Federal PLUS Loans, and Subsidized and Unsubsidized Federal Consolidation Loans. Funds are provided by private lenders such as banks, credit unions, and other private financial institutions. The loans are backed by the Federal government.

Grace Period: After borrowers graduate, leave school, or drop below half-time enrollment, loans that were made for that period of study have several months before payments are due. This period is called the "grace period." Grace periods extend from 6 to 12 months after borrowers leave school:

- Most FFEL and Direct Loans have 6-month grace periods.

- Other subsidized loans have grace periods of either 6 or 9 months, depending on when the loan was first disbursed.

- Health professions loans have grace periods of 9 to 12 months.

During the grace period, no interest accrues on Subsidized loans. Interest accrues on Unsubsidized loans during grace periods, and this interest is capitalized when borrowers' loans enter repayment.

Prepayment: A prepayment is an amount in excess of the amount due on a loan. If borrowers have more than one Direct Loan, they must specify which loan they are prepaying. Like all other Direct Loan payments, a prepayment first will be applied to any outstanding fees and charges, next to outstanding interest, and then to the principal balance of the

loan(s). There is never a penalty for prepaying principal or interest on Direct Loan Program loans.

Promissory Note: The binding legal document that borrowers sign when they obtain loans. Promissory notes define the conditions under which funds are provided and the terms under which borrowers agree to pay back the loan. Promissory notes include information about the interest rate and about deferment and cancellation provisions.

Reasonable and Affordable Payments: Rehabilitating a defaulted loan or making satisfactory payment arrangements requires borrowers to make "reasonable and affordable" payments. The holder of a Direct Loan or FFEL Program loan determines on a case-by-case basis what constitutes a reasonable and affordable payment on defaulted loans. Loan holders consider disposable income and such expenses as housing, utilities, food, medical costs, work related expenses, dependent care and other Federal education loan debt. Borrowers are then provided with a written statement of the payment and an opportunity to object to those terms.

Rehabilitation: The process of bringing a loan out of default and removing the default notation on a borrower's credit report. To rehabilitate a Direct or FFEL loan, a borrower must make at least nine full payments of an agreed amount within 20 days of their monthly due dates over a 10-month period. (Rehabilitation terms and conditions vary for other loan types. Check with your lender for details.)

Satisfactory Repayment Arrangements: Borrowers in default on Direct Loan and FFEL Program

loans who wish to consolidate their loans in a plan other than the Income Contingent Repayment (ICR) plan must have made satisfactory repayment arrangements with the loan holder(s). Three consecutive, voluntary, on-time monthly payments on a defaulted Direct Loan or FFEL Program loan constitute satisfactory repayment arrangements. Borrowers must work with their current loan holders to set up reasonable and affordable payments.

Separation Date: The actual or anticipated date when the borrowers graduate, leave school, or drop to a less than half-time status. The separation date is used to determine the loan's grace period and the date the first loan payment will be due.

This last definition is an important one. A common way to manage heavy student loan debt is to stay in school at least half-time. Going back to school half-time can also work; as long as you aren't already in default, you can use your half-time status to get existing loans deferred and buy yourself time to set up a strategy for repaying them.

LOAN FORGIVENESS PROGRAMS

If you are a full-time teacher for five consecutive academic years in a "low-income" school, you may qualify for a federal loan forgiveness program.

(There are also other loan-forgiveness programs that federal and state agencies offer for people working in law enforcement, emergency response, medicine

and other fields. Since the low-income teacher program is one of the largest and oldest, we will consider it as the loan-forgiveness template.)

To qualify, you must meet the following conditions:

- you must have taught full time for five consecutive complete academic years in an elementary or secondary school designated a "low-income" school by the U.S. Department of Education;

- at least one of the qualifying years of teaching was after the 1997–1998 academic year;

- your loan must have been made before the end of the fifth year of qualifying teaching;

- the school must be public or private nonprofit.

The program doesn't take effect automatically. You have to apply—and submit a completed application to the chief administrative officer at your school. He or she must certify:

- that you have taught full time for five consecutive years at that school, and

- if you're teaching in an elementary school, that you have knowledge of or teaching skills in areas of the elementary curriculum;

- if you're teaching in a secondary school, that you are teaching in a subject area relevant to your academic major.

When your application is completed and certified, you must submit it to your loan servicer for processing and review. Most lenders will require at least 30 days to review the application.

DISABILITY CANCELLATION

If you are totally and permanently disabled, you may be eligible for **cancellation of your student loans**. This relief is called "discharge." A final discharge due to total and permanent disability cancels your obligation (and any endorser's obligation) to repay the balance of your loan.

> **Your condition must not have existed when your student loan was made unless your condition has substantially deteriorated so that you are now totally and permanently disabled.**

"**Total and permanent disability**" is defined as a condition that keeps you from working or earning money because of an injury or illness that is expected to continue indefinitely or results in death. To be eligible for this discharge, you must provide certification of your total and permanent disability from a physician of medicine or osteopathy who is licensed to practice in the U.S.

You and your doctor will need to make sure that this certification **matches exactly the form and style required by the Department of Education**. The best approach is to get the Department's "Loan Discharge Application: Total and Permanent Dis-

ability" (check the Department's Web site at www.ed.gov/offices/OSFAP/DCS/forms.html) *before* you get the doctor involved. Most of the applications that are denied have problems related to incomplete or imprecise certification.

You may be eligible for Social Security disability benefits but *not* be eligible for the discharge of student loans. The Department of Education has its own rules for disability benefits. Specifically, you must meet the definition of "total and permanent disability" provided in Section 5 of the Loan Discharge Application: Total and Permanent Disability.

Some other points to know when you're applying for a disability discharge:

- The Department of Education requires doctors to use laymen's terms when certifying an application.

- Medical abbreviations are not accepted.

- The standard for loan discharge is not whether you can do your job but, rather, if you can work and earn money in *any* capacity.

- Ongoing treatments do not make you automatically eligible: People receiving such treatments are sometimes able to return to work.

- If you received a FFELP loan after the date your physician certified that you

are unable to work, your application will be denied.

If the discharge of the loans is approved, it will appear as a transfer (to the guarantee agency) on your credit report. This may require some explanation to future lenders—and the Department of Education can provide a form letter explaining the transfer—but it's **better for your credit than a default**.

The "dirty secret" of the student loan industry is that many of the private loans made to college and university students are high-interest products—little better, in financial terms, than credit card debt.

The main mechanism for renegotiating student loans is the consolidation of several loans into one larger account. The recession that started in 2007 made this process difficult, as several of the largest private-sector lenders in the consolidation market pulled back from new business. But the Department of Education has designed programs to encourage these deals.

Beyond consolidation, most of the tactics for renegotiating student loans are bureaucratic and time-consuming. If you're having trouble making your student loan payments, your best chance for relief is to **spend your time searching for a consolidation lender that will offer better terms**.

7

PAYDAY LOANS, CASH ADVANCES AND OTHER BAD DEALS

Payday loans are designed not to be renegotiated. The nature of the things is that the lender has the right to access your bank account (either electronically or by presenting a check) for the full amount of the loan at any time after a specified date. This is a practical kind of security that the lender will rarely surrender or reconsider.

In effect, the only way to cram down a payday loan is to close the account to which the lender has access. And, payday loan companies insist, many people do exactly that—which is why the lenders charge the high interest rates that they do.

Closing your bank account to force the renegotiation a relatively small loan (the principle amounts of payday loans are rarely more than $800) will usually do more harm than help to your finances. In most cases, your best way out of a payday loan will be to ask the lender to "term out" the balance— allow you to make partial principle payments—at a

lower interest rate than first agreed. To this, most lenders will say "no." Payday loans are difficult; in this chapter, we'll consider the best tactics for success in managing them.

But, first, we'll take a quick look at the mechanics of payday loans. And why the best way to manage them is to **avoid them entirely**.

THE UGLY DETAILS

There's an old, cynical saying among bankers: "The perfect loan is one in which the borrower is in technical default immediately but still manages—just barely—to keep making the payments." The idea is that the lender gets its payments every month but can recall the loan at any time it chooses.

In this sense, payday loans are "the perfect loan." Their interest rates are very high. Their terms are hard to manage well. Even their defenders suggest the loans should only be used in emergencies. The problem is that some people consider a weekend trip an "emergency."

> **Payday loans are attractive to high-risk consumers who cannot obtain traditional credit from a bank or credit union. They tend to be small, short-term, single-payment loans with exorbitant interest rates. A $300 loan that costs $50 for two weeks in order to tide over a car payment can end up costing $700 in a few months, and maybe even thousands by the time the borrower finds a way to pay it off.**

These payday or "cash advance" loans are granted based on steady employment. The borrower writes a postdated check or agrees to an electronic withdrawal from his checking account, in the amount of the cash advance plus a fee of between 12 of 25 percent. By agreement, the lender will withdraw the money from the borrower's account on the next payday (usually a maximum of two weeks later).

Again, that's an interest payment of 12 to 25 percent for **a loan term of two weeks**.

> **The best way—and, in most cases, the *only* way—to manage a payday loan is to pay it off as soon as possible.**

If the borrower can't repay in time, he or she can let the loan deadline "roll over" another two weeks—and another fee is tacked on. In most cases, the borrower has to pay the previous interest payment in order to roll over the principle amount of the loan.

> **Following this model, a person who borrows $300 (a common maximum loan to first-time borrowers) can end up paying over $2,000 in six months.**

One useful rule of thumb: If a borrower rolls over one of these short-term loans more than four times per year, he or she is financial trouble.

And lots of people end up in trouble because payday loans are trouble by their nature. The results are inevitable, as Washington D.C. city council member Mary M. Cheh told a local newspaper:

> *Less than one percent of the borrowers are able to pay {payday loans} back in two weeks. {Payday lenders} don't provide short-term loans. They create long-term debt, and that's the whole point.*

Soon after, in September 2007, the D.C. City Council approved legislation that required payday lenders to charge the same interest rates that banks and credit unions charged for consumer loans.

This meant payday lenders couldn't charge more than 24 percent annual interest (or the equivalent in fees); for a two-week loan, the maximum interest charge was about $0.92 per $100. The previous D.C. law had allowed fees as high as $16.11 per $100 plus interest.

The law effectively put payday lenders in the city out of business.

The Community Financial Services Association, which represents payday lenders, said that the D.C. City Council had made a mistake—and that unregulated lenders operating on the Internet would fill the void. And, by most accounts, they did.

Who was agreeing to these terrible loans? And why were they doing it?

WHY PAYDAY LOANS EXIST

The most common defense for payday loans goes something like this: A person has three bills due on Wednesday but doesn't get paid until Friday. If he bounces a check for one of the bills, he pays $60 in bank fees—if he bounces three checks, he pays $180. So, it makes sense for him to take a payday loan instead of bouncing three checks.

This defense fails in a couple of significant ways. First, returned check fees are among the worst abuses in the consumer banking industry—so, using them as the comparison that justifies payday loans amounts to the old rhetoric trick of defining deviancy down.

Second, as the D.C. City Councilwoman indicated, very few borrowers repay the payday loan right away. Instead, they get hooked into a cycle of interest payments that makes bounced-check fees pale in comparison.

If a borrower is aware of the terms and costs, he will avoid payday loans.

But this is a book about *renegotiating* debts. Is there any way to renegotiate a payday loan? Not exactly…and what's possible isn't pretty.

According to the Federal Trade Commission:

> *The federal Truth in Lending Act treats payday loans like other types of credit: the lenders must disclose the cost of the loan. Payday lenders must*

*give you the finance charge (a dollar amount)
and the annual percentage rate (APR—the cost
of credit on a yearly basis) in writing before you
sign for the loan. The APR is based on several
things, including the amount you borrow, the in-
terest rate and credit costs you're being charged,
and the length of your loan.*

A payday loan—that is, a cash advance secured by
a personal check or paid by electronic transfer—is
very expensive credit.

WHO ALLOWS PAYDAY LOANS

Traditionally, most states capped small loan rates at
24 to 48 percent annual interest and required in-
stallment repayment schedules. Some states also
have criminal usury laws (for example, New York's
usury cap is 25 percent annual interest—charging
more than that is a crime).

Payday loans are legal in states where legislatures
exempted lenders from small loan or usury limits
under the theory that cash "advances" are different
than loans.

> For example, Arkansas law caps loan rates at 17
> percent annual interest—but permits check cashing
> firms to make higher-interest, single-payment loans
> secured by postdated checks. Oregon, on the other
> hand, requires at least a one month loan term and
> caps rates at 36 percent annual interest plus a one-
> time fee of $10 per $100 borrowed.

In the late 1990s and early 2000s, the number of states allowing payday loans increased. But starting in 2004, a number of these states went back to their usury limits or created new laws prohibit payday loans.

In 2009, about a dozen states had laws or usury caps that effectively prohibited payday lending at triple-digit annual interest rates.

But most states allow loans secured by checks written on borrowers' bank accounts to charge interest rates above the usury caps. In fact, the paydays lenders can charge triple-digit annual interest rates—though they don't advertise this fact.

The states that (as of 2009) allow payday loans are:

> Alabama; Alaska; Arizona; California; Colorado; Delaware; Florida; Hawaii; Idaho; Illinois; Indiana; Iowa; Kansas; Kentucky; Louisiana; Michigan; Minnesota; Mississippi; Missouri; Montana; Nebraska; Nevada; New Hampshire; North Dakota; Ohio; Oklahoma; Rhode Island; South Carolina; South Dakota; Tennessee; Texas; Utah; Virginia; Washington; Wyoming.

ALTERNATIVES TO PAYDAY LOANS

As a result of public outcry against the terms of payday loans, some lenders have developed lower-cost alternatives to payday loans that have better repayment terms.

Payday loan alternatives should have these features:

- At least a 90-day repayment term, re-payable in installments;

- No personal check mechanism or other unfair collateral (such as a car title);

- Reasonable limits on renewals

With payday alternatives, borrowers pay late fees or penalty fees only one time.

That's what more reasonable short-terms loans might look like. But *existing* payday loans remain difficult to renegotiate. The best plan is avoid them completely. Here are some common alternatives:

- Some employers grant paycheck advances to employees. Because this is a true advance, and not a loan, there is no (or very little) interest.

- Contact your creditors—and ask for more time. Many may be willing to work with consumers who they believe are acting in good faith. They may offer an extension on your bills.

- Contact your local consumer credit counseling service if you need help working out a debt repayment plan with creditors. You can find an accredited consumer counseling agency in your area by calling 1-800-388-2227 or visiting www.debtadvice.org.

- Find out if your bank offers overdraft protection on your checking account. If you are using most or all the funds in your account regularly and you make a mistake, overdraft protection can help protect you from further credit problems. Find out the terms of the overdraft protection; it can be costly (but still less than a payday loan).

- Consider a loan from your credit union or traditional bank. Some banks may offer short-term loans for small amounts; most credit unions offer small, short-term loans to their members.

For example, North Carolina State Employees' Credit Union offers members a salary advance loan at 11.75 percent annual interest—30 times cheaper than a typical payday loan. Many other credit unions offer lower interest rate loans (under 18 percent APR) with quick approval on an emergency basis.

- Some consumer finance companies offer small, short-term loans that cost up to 60 percent, usually in the range of 25 to 36 percent APR.

These loans are also much cheaper than payday loans; a person can borrow $1,000 from a finance company for a year and pay less than a $200 or $300 payday loan over the same period.

- Contact nonprofit organizations. A local community-based organization may make small business loans to people. Many faith-based groups and community organizations provide emergency assistance, either directly or through social services programs.

> For example, the federal Low Income Home Energy Assistance Program provides financial assistance to low-income households that are have weather-related cash emergencies.

- A cash advance on a credit card also may be possible. Even a credit card's high cash-advance rate will usually be better than a payday loan.

> Most credit card cash advances have and interest rate of about 30 percent APR. That's still bad but much cheaper than getting a payday loan.

Some credit card companies specialize in consumers with financial problems or poor credit histories. So, shop around online—and don't assume you won't qualify for a credit card. You might be able to find **a modest card with enough credit to avoid a $300 payday loan** that becomes a $2,000 debt.

The point is: Shop for the credit offer with the lowest cost. Compare the APR and the finance charge,

which includes loan fees, interest and other credit costs. You are looking for the lowest APR. Payday loans don't come even close.

LIMITS ON PAYDAY LOANS

Military personnel have special protections against extremely high fees or rates. The U.S. Department of Defense put rules in place (and congress did pass a law supporting the rules) because military families were being marketed aggressively by the payday loan industry.

> The rules put in place but the Pentagon also serve as a kind of blueprint for how *all* consumers should think about payday loans.

For a payday loan offered after October 1, 2007, the military annual percentage rate cannot exceed 36 percent. Most fees and charges, with few exceptions, are included in that rate.

Lenders may not require use of a check or access to a bank account for the loan, mandatory arbitration, and unreasonable legal notices. Military consumers also must be given certain disclosures about the loan costs and your rights. Credit agreements that violate the protections are void. Creditors that offer payday loans may ask loan applicants to sign a statement about their military affiliation.

As we mentioned before, these guidelines are worth following—even if you're not in the military. And

the fact that the Pentagon refuses to support mandatory arbitration clauses indicates that they aren't good for the borrower.

Several companies offer loans ranging from $500 to $10,000 to active duty and retired military personnel. Payday loans are 10 to 13 times more expensive than these small consumer loans. These loans cost less than payday loans because they have much lower APR, ranging from 30 to 35 percent.

Why did the Pentagon feel obligated to make these rules? Because payday loans tend to create cycles of debt from which borrowers have a hard time escaping. According to a November 2006 report from the Center for Responsible Lending, payday loans drag borrowers into permanent debt "with $4.2 billion in predatory fees every year."

Specifically, the CRL industry survey stated:

> *Every year, payday lenders strip $4.2 billion in excessive fees from Americans who think they're getting a two-week loan and end up trapped in debt. This report finds that across the nation payday borrowers are paying more in interest, at annual rates of 400 percent, than the amount of the loan they originally borrowed.*

Other conclusions from the 2006 CRL survey:

- Payday lenders collected 90 percent of their revenue from borrowers who could not pay off their loans when due, rather than from onetime users dealing with short-term financial emergencies.

- That 90 percent number was virtually unchanged from CRL's previous industry survey, completed in 2003.

- The typical payday borrower pays back $793 for a $325 loan.

- States that ban payday lending save citizens an estimated $1.4 billion in payday lending fees every year.

Finally, according to CRL president Michael Calhoun:

> *Payday loans are marketed as short-term cash advances on the borrower's next paycheck. But previous research has found—and this study confirms—the industry depends on repeat business or "flipped" loans. ...Borrowers end up paying more in interest—at rates of 400 percent—than the amount they originally borrowed. But by addressing payday lending squarely with a 36-percent APR cap, state lawmakers can get working Americans back on solid financial ground.*

LENDERS RUNNING SCARED

In spite of public scrutiny and recent attempts by state policymakers to reform the practice, repeat loans have only been eliminated in states that don't allow payday lending. These "safe" states—Connecticut, Georgia, Maine, Maryland, Massachusetts, New Jersey, New York, North Carolina, Pennsylvania, Vermont, and West Virginia—hold all lenders to their consumer loan laws, which usually include a double-digit interest rate cap.

In January 2009, some media outlets reported that President Obama planned to limit the annual percentage rate cap to the same cap put in place for military families, which is 36 percent.

The payday loan industry rallied against reports of the 36 percent cap. According to Steven Tarlow, writing for a Web site called "Your Payday Loan News Source":

> *This will drive no fax payday loan companies out of business because the rate is unsustainable. Not only is the risk involved in offering unsecured, no credit check payday loans tremendous, but any operating business has operating costs.*
>
> *...calculate what kind of profit a 36 percent APR faxless payday loan would garner for a business. For a $300 payday loan that is to be repaid in two weeks, cramming that unsecured two-week loan into a 36 percent APR straitjacket means that the compensation a lender receives is $4.14. That's all. How is a lender going to pay their business operating expenses and employees with that?*

The standard line from payday lenders is that their loans do not, by themselves, lead to bankruptcy; if an undisciplined consumer is already in trouble financially but does qualify for a loan, that loan may provide extra cash as designed.

> **Indeed, a payday loan will not turn around a person's long-term habits. Only self-discipline and mature financial planning will do that.**

Nationally, nearly $5 billion per year is stripped from the earnings of working people and transferred to predatory lenders through practices like payday lending and other types of high-cost lending—such as car title loans and "tax refund anticipation" loans..

No one *plans* to be **trapped in high-cost debt for weeks or months**, but that's what happens with payday loans. Salary cuts, job losses, higher prices for gas, food and housing can quickly cut into a family's budget, making cash shortfalls more likely— and payday loans more dangerous.

Quick-cash schemes contribute to bankruptcies and the "unbanking" of Americans. According to one econometric survey, bankruptcy is more likely for payday loan borrowers than people who *could not qualify* for payday loans. The people approved were **twice as likely to end up in bankruptcy**.

> **Specifically, an increase in the number of payday lending locations in a particular county is associated with an 11 percent increase of involuntary bank account closures, even after accounting for county per capita income, poverty rate, educational attainment, and a host of other variables.**

A 2008 report titled "Bouncing Out of the Banking System: An Empirical Analysis of Involuntary Bank Account Closures" (written by Harvard Business School professors Dennis Campbell, A.M. Jerez and Peter Tufano) found that payday loans put people's **ability to have a bank account at risk**.

> The report (available online at the Boston Federal
> Reserve Bank's Web site) concluded that payday
> loans caused multiple overdrafts which, in turn,
> caused the accounts to be closed.

Payday loan industry representatives have lobbied
for other reforms, such as payment plans and limits
on loan amounts—because these measures **do little
to limit their ability to flip loans** to the same bor-
rowers. (And, as we've pointed out, that flipping is
the real profit strategy with payday loans.)

There's **no effective way to cram down a payday
loan.** In most cases, the lender has your check…or
(worse) your checking account information. If you
let the "check" bounce and close the account, you
end up in worse shape. And the lender comes after
you with criminal fraud charges. You can try to
argue against the legitimacy of the transaction—
but this will often end up with you spending thou-
sands of dollars on penalties and legal fees to fight
over hundreds of dollars in loans.

The bottom line on payday loans: Try to find an
alternative. If you must use one, limit the amount.
Borrow **only as much as you can afford to pay
with your next paycheck.** And do everything you
can to end it there.

CHAPTER 8

PHONE PLANS

Mobile phone service contracts are sneaky things. Often, they're not very good for you, the consumer; but service providers are **creative about hiding the bad terms**.

The biggest trick the companies have for hiding the details is **hardware**—they count on your excitement about a certain model of cell phone to blind you to the fine print of how you can use it.

> **The best-known example of this phenomenon was the early incarnation of the Apple iPhone. It was a fashionable device that came with a relatively undesirable service contract (through AT&T). Fashion trumped fiscal sense. The iPhone was a huge hit, despite the bad plan.**

As a result of the service companies' cagey marketing, some people get stuck in cell phone plans that can't afford or don't need. So, there's cause for renegotiating—and sometimes *re*-renegotiating—cell

phone plans. This chapter will consider various strategies and tactics for getting out of a bad one.

CANCELLATION FEES

The biggest hurdle to getting out of a bad cell phone plan is the **cancellation fee** that the provider will charge to let you leave the contract early. Most cell phone contracts last two or three years. In exchange for a particular phone model—or a desirable number of call minutes or unlimited text messages or other features—you agree, over the contract's term, to pay an amount each month according to by a predetermined formula.

In some cases, you may not realize that the formula includes fees and penalties that **raise your actual payments** far above the advertised rate. You complain, are advised by the service provider to review your contract, and then (having determined that the higher payments are legit) ask how much it will cost to cancel. In many of *these* some cases, the cancellation fee will be determined by its own complex formula...that often ends up equaling your average monthly payment multiplied by the number of months left in the contact.

Some cancellation fees are more reasonable than this. Usually, the worse the cell phone plan, the higher the cancellation fee (in this way, these fees are like early termination fees or prepayment penalties associated with financial products like mortgages, car leases, etc.).

If your cancellation fee is high, it will make quitting a bad financial move. (That's the objective.) But that doesn't mean you should give up on getting a better deal—it just means that you'll need to concentrate on convincing your existing service provider to modify your existing contract to make it better fit your needs.

If your service provider can't meet your needs and you want out of your contract before it expires, consider using a service, such as Celltradeusa.com or Cellswapper.com. These Web sites connect users who want out of their deals with people interested in taking over contracts for shorter periods.

While not a common practice, switching users is legal and can help you avoid high cancellation fees.

NEGOTIATION POINTS

Here are some steps you can to take to get ready to renegotiate your phone plan:

- Know what plans other service providers in your geographic area offer.

- Contact other providers and determine what they'll offer to get your business.

- Ignore promotional offers (especially ones involving new phone models) and focus on plans with the minutes, texting allowances and features you use most.

Even if you don't change plans, knowing these details and the related costs will allow you to renegotiate your existing contract in better detail. And with more practical expectations. It will help you

know the **market rate**—what other service providers are charging for packages like yours.

A negotiating tip: The best phone renegotiations happen when you're within six months of the end of your contract. Within three months works even better. Your company needs to understand that you can and will move to another service provider if you don't get the deal you want.

Once you've done your intelligence-gathering, it's time to contact your cell phone provider. Consider following these steps (in addition to the normal note-taking and temperament points we recommended in Chapter 1):

1) Ask to speak to a manager or supervisor right away. Try this line: "My contract is up in X weeks and I am considering switching providers. Would you please transfer me to a retention specialist?"

2) When you get through to a manager, describe the other phone plans that are available—and mention that you've been in touch with other providers. State clearly the service package and monthly rate that you'd like to stay with this company.

3) As ever, don't accept the first offer. In this situation, be aware that the first offer will likely be a credit toward an

upgraded phone (in other words, "look at the shiny hardware") or a onetime rebate on your next bill.

4) Don't take no for an answer. If the first manager you contact gets cagey or refuses to give you the package you want, escalate the call to his manager. Like most larger service providers, phone companies aren't as coordinated as many consumer think. You may get a better response.

5) Ask for a detailed breakdown of what you'll pay for new services when you renegotiate cell phone contracts before you agree to the new terms. The agent may neglect to mention activation fees or additional equipment charges that will up the cost of your first month's bill.

Check the new agreement sent by your cell phone service provider after you renegotiate cell phone contracts to ensure the details you'd agreed upon (and no additional, unwanted services or "free trials" for cellular service features) are in the document.

TIMING CONTRACT TERMS

When you renegotiate cell phone contracts, be aware that you may have to renew your entire cellular service plan for one or two years, depending on your cell phone service provider. These renewals are extremely important to most service providers—in the increasingly competitive telecom market, most com-

panies make a big deal about keeping existing customers. One woman posted online about her experience in parlaying her contract renewal into a hardware upgrade.

She and her husband had been with Sprint for almost two years. Their overall experience had been good—but their phones were aging and lacked the functionality of newer models. As their two-year our contract was getting close to ending, Sprint sent a postcard offering her a $100 credit toward new hardware if she would sign another two-year contract. She suspected they could do better.

> *I researched other cell providers and called to see they would give us to switch. Sprint's competition naturally salivated like Pavlov's dogs and promised us the proverbial keys to the castle if only we would sign up with them....*

She called Sprint and had a long conversation with a customer retention manager. Finally, he offered her any two phones currently offered for free on Sprint's Web site if she'd renew her plan.

She said that she didn't want to buy a phone unless she'd seen it in person. He noted his offer in her account and they agreed she would call back later. On reflection, she decided that two free phones weren't enough to keep her business.

> *...I call Sprint back, get transferred to a retention specialist right away and I tell her exactly what we want. She looks at our account and then asks me to hold for one moment, presumably to consult with someone.... In a couple of minutes,*

she's back on the line and gives me the good news. Yes, she can give me those two expensive, not-free-on-the-Web site phones for free if we sign up for another two years.

DESIGNED TO BE CONFUSING

The actual cost of a cell phone contract is confusing—and it's designed to be that way.

As bad and confusing as cell phone service plans may be, they are more economical than the options— paying for service on a "month to month" basis or using a "prepaid" service. Both of those end up even more expensive than a suboptimal plan.

Here is a breakdown of costs in one standard cell phone contract:

- 1,000 peak-time minutes per month at $79.99;

- every minute over 1,000 minutes costs $0.40;

- unlimited "in-network" calling to anyone who has a contract with the same carrier is free;

- weekend and evening use of the phone after 9 p.m. is free;

- long distance and roaming are free.

This a pretty good plan; the free long distance and roaming are desirable features. Still, it's possible for a heavy phone user to go over 1,000 minutes in a month; and texting fees and Internet access aren't covered in the fixed portion of the package—a heavy text user would likely run up **substantial additional costs**. (And *international* texts, which normally cost between $0.25 and $0.50 each, can really raise the monthly total.)

So, even though this decent plan is marketed as costing $79.99 a month, it could easily cost you twice that amount—if you talk a lot, text a lot or use the Internet.

This situation is ripe for a renegotiation.

FINDING A BETTER PLAN

Cell phone service providers count on people's laziness to keep them in plans and contracts that don't work as well (that is, as cost-effectively) as they should. This is a shame, because the various **features of phone plans are modular**—and can be combined in customized packages, tailored to each consumer's needs.

The challenge is that, to get the right customized package, you have to **ask a lot of questions and be a little pushy**. Most people don't want to be that—so, instead, they continue to pay their monthly bills for services that should either cost less or provide more.

One telecom industry expert describes the way most people deal with plans they don't like:

> *I'm disgusted every month when the bill comes due. This month, I vow, something must change. Before I know it, next month's bill arrives and I haven't changed my usage habits, my carrier, or my plan.*

You don't have to be that person.

A number of Internet Web sites compare various phone plans by geographic location, minutes, features and other measurements. Among the most popular of these sites:

- letstalk.com,
- myrateplan.com,
- phonedog.com,
- wirefly.com.

Consumers Union (Web site: ConsumerReports.org) also does some good plan comparisons.

Most of these sites allow you to enter phone models and plan features you want and see what the major service providers offer.

As we've noted before, knowing what other carriers offer is an important part of negotiating a better deal with your current provider. Of course, timing is important, too. The closer you are to end of your contract, the more leverage you have.

One approach that some heavy users take is to find friends or extended family members willing to join together on a **family mobile phone package**.

Family plans are much cheaper, per user, than individual plans. And, since many plans include free or very cheap long distance service, the area code on the phones doesn't matter so much—even if the cost-sharing family members are on different coasts.

For example: Two brothers may each be paying over $100 a month for a individual service plans. Joining together, they can pay for one plan and an additional phone on that plan for as little as $10 a month. Using a single contract, they can cut their base expense nearly in half.

This kind of savings can make it worthwhile to cancel an existing cell phone contract—even if you are in the early stages of that deal.

Of course, to make a family plan work well over the long term, you'll need to make sure of a few things:

- you have enough combined minutes each month to divide among the family members;

- you agree on which features the plan will include and that those features won't change over time;

- the person whose name is on the contract is trustworthy—both for keeping

the account current and managing pay-
ments from other family members;

- all family members understand clearly
 in advance who expected to pay what
 and how much each month;

- all family member understand how and
 why new family members can join the
 plan—and existing members can drop
 or be dropped.

The biggest downside to sharing a family plan with
extended family members is the potential for per-
sonal issues to flair up that compromise the smooth
management of the plan. Make sure the family
members are people you'll be comfortable doing
business with.

Evaluating cell phone contracts can be confusing,
overwhelming and time-consuming. There are
enough features with cellular phone programs to
make anyone's head spin—and cell phone service
providers know this. Still, with potential savings of
between $500 and $1,000 a year, it certainly can
pay to keep an eye out for better plans.

Here are a last few points to keep in mind, if you
prepare to leave a cell phone plan during a contract
term:

- make sure that leaving the cell phone
 plan won't affect any other telecom ser-
 vices you use—land lines, DSL or other

Internet connections, TV service. The bundling of several services is a common way telecom companies try to keep customers locked in;

- make one last call to a customer retention manager before you quit the contract. **Retention deals are constantly changing**, so there might be something new and rich enough to make the plan worth keeping;

- ask your carrier to clear out your personal information on a previously used phone. You may be able to sell the phone, get a discount on a new phone, or do something to get some value out of your old hardware.

Mobile phones have become a practical necessity of modern living. In fact, a growing number of Americans have stopped using land line phones—are do all of their communicating wirelessly. Because wireless service is a relatively competitive market (a rare thing, anymore) costs are fluid.

A better deal is almost always available, if you'll take the effort to find it.

9

TAXES

In the fiscal year ending September 2008, the Internal Revenue Service took "enforcement actions" against more than three million taxpayers. These actions included property liens and asset seizures—including homes, cars, bank accounts and garnished wages. Under the Barack Obama administration, the IRS will likely increase the aggressiveness of its collection activities. And the various state-level tax agencies follow the Feds' lead.

> In order to negotiate a tax debt effectively—especially if you've drawn the attention of tax authorities—you usually need to hire an attorney.

However, the spirit of this book is renegotiating debts yourself; so, in this chapter, we will review the normal ways that tax debts can be managed, negotiated and settled. You can do *some* of these things yourself—but **the U.S. tax code is stacked heavily against tax debtors**. This isn't like negotiating a credit card bill.

One quick example: in most cases, tax debts can't be discharged in bankruptcy proceedings. In addition to having the law on their side, tax collection agencies also have more lawyers—both employees and contractors who help them work the court systems to their advantage. So, we'll say again:

In order to negotiate a tax debt effectively, you usually need to hire an attorney.

Consider this chapter a primer on the mechanics of tax negotiations that will allow you to talk to your lawyer in an informed manner. Or choose a lawyer in an informed manner. Or check up on your lawyer's progress effectively.

Not filing a tax return is always a bad strategy. If you think that not filing will somehow work to your advantage, **you're almost certainly wrong**. If someone is giving you advice that includes not filing taxes, that person is either a fool or a crook.

If you don't file, you lose control of the process—the IRS may take an educated guess about what your tax liability might be and use that guess as the basis for a "proposed assessment" or even filing a return on your behalf.

A "**Substitute for Return**" (SFR) is the formal way that the IRS makes an educated guess about how

much tax you might owe. The purpose of an SFR is to arrive at a definite dollar amount of your tax liability, so that the IRS can begin collection efforts.

The IRS uses its substitute tax return to issue a proposed assessment of taxes you owe. If you don't respond to the proposed assessment, that assessment may become final. Once the assessment becomes final, the IRS can now legally collect that tax.

> **The best way to resolve a Substitute for Return is to file an actual tax return. And, if you haven't filed taxes in a few years, filing returns (no matter how late) can be the quickest way out of trouble.**

The IRS *must* accept a tax return with your signature attached.

IRS COLLECTION TACTICS

IRS collections efforts typically include **issuing tax liens, garnishing paychecks, levying bank accounts** and **seizing vehicles**, personal or business property, real estate or other assets.

First, and most often, the IRS will file a **Notice of Federal Tax Lien** that is recorded in the county where you live. It can also serve a Notice of Levy upon your employer to attach your wages or upon your bank to attach any money you have in accounts there. Less often, it will seize an asset—such as a vehicle, a business or even a home.

A lien is merely a paper document. Unless you are a homeowner, it doesn't do much damage—except to show up as a black mark on your credit report. The lien attaches to all property you own or acquire after the fact; but it's only valid in the county in which it is filed. So, if you own property in Texas but the lien was filed in California, you can sell the Texas property free and clear of the lien.

A levy attaches to a specific item—in most cases, either wages or a bank account. A levy on your wages is considered to be continuous; it will keep attaching your wages, until the IRS agrees to stop or until the debt is fully paid. A bank levy is different; it attaches only the money in the account at the moment it's received by your bank. Deposits or other transactions you make later—even later that same day—aren't affected.

A note on bank levies: You have 21 days to work something out with the IRS and negotiate for some or all of your money back. Under the law, the bank removes the money from your account, but does not send it to the IRS for 21 days.

There are a number of ways to halt IRS collections activities, including negotiating with the collections manager handling the case or seeking either of two kinds of hearings: **collection due process** or **collection appeal process**.

Both the collection due process and the collection appeal process hearings involve expedited confer-

ences with the IRS Appeals Office to review deci-
sions on liens, levies or seizures. The key difference
between these programs is that the collection ap-
peals program doesn't allow further appeal to a
court; the collection due process does.

Setting up a **monthly payment plan** with the In-
ternal Revenue Service is easy. (In IRS jargon, a
monthly payment plan is called an installment
agreement.) Either you or a tax professional can set
up an agreement quickly over the phone or by fill-
ing out some basic paperwork.

> **You can set up a monthly payment plan with the IRS
> to pay less than the full amount of your tax debt.
> This is called a partial-payment installment agree-
> ment, and can be easier to get IRS approval on than
> an Offer in Compromise or other type of settlement.**

There's no such thing as a "discharge" of an IRS tax
debt. The closest thing to a discharge—a declara-
tion of "Currently Not Collectible" status—means
that a taxpayer has no ability to pay his or her tax
debts. The IRS can declare a taxpayer currently not
collectible after it receives evidence that a taxpayer
has no ability to pay (this evidence can include a
bankruptcy notice).

TAX AMNESTY: NOT FROM FEDS

The purpose of Tax Amnesty programs (and related
"Voluntary Disclosure" programs) is to encourage
people to file and to pay their back taxes. In return,

the tax agency offers to reduce fees and penalties—
or waive them entirely.

In order to qualify for the waiver of penalties, the
taxpayer must pay the entire amount of taxes due,
plus any interest, by the program's deadline. Also,
the taxpayer may have to sign a settlement agree-
ment in which the taxpayer agrees to file and to
pay all taxes on time in the future.

**A Tax Amnesty program provides comprehensive
tax relief—at the state level. There is not now, nor
has there ever been, any form of Tax Amnesty on the
federal level.**

Typically, an amnesty program has a small window
of opportunity. The goal is to collect as much back
taxes as possible in a short period of time, usually
two or three months. Generally, the state will waive
penalties if you file returns and pay your taxes dur-
ing the amnesty period. And it will usually impose
larger than normal penalties—if you fail to take ac-
tion during the amnesty period.

A **Voluntary Disclosure** program tends to be more
open-ended. They encourage people to file and to
pay their back taxes without the state having to
contact the person first. If you have received a letter
from the state asking you to file a return, or pro-
posing that you owe more taxes, you will not usu-
ally qualify for a Voluntary Disclosure program.
Some states have ongoing programs—which means
there is no set deadline.

A hybrid of the two programs is called a **Voluntary Compliance Initiative**. The initiative runs for a short period of time and targets taxpayers in specific situations. However, the tax agency (usually) doesn't know who these taxpayers are in advance.

OFFER IN COMPROMISE

Media reports or (more often) advertisements about "settling tax debts for pennies on the dollar" usually refer to an IRS negotiation tool called **Offer in Compromise (OIC)**. If you qualify for an OIC (and that's a big *if*—there are various conditions you have to meet), the IRS may accept as little as one percent of the amount you owe.

> Although an OIC is the best-known form of tax-debt negotiation, other less-procedural types of negotiation exist. Depending on your circumstances, you (or, more precisely, your attorney) may be able to negotiate directly with an auditor, collector, appeals officer or attorney. These IRS staffers may be willing to settle or concede certain tax debts in order to "close your file" and report the matter completed. This is especially true if your circumstances make litigation risky. These "attorney-to-attorney" (even if the IRS person isn't, literally, an attorney) avenues should be explored before pursuing an OIC.

Since the 1950s, federal tax law has allowed the IRS to settle tax liabilities for less than the total due. But it wasn't until the early 1990s that the Feds started accepting OICs on a routine basis.

Very quickly, OICs became a big business—too big, by some reckoning. One reason that so many people filed OICs is that, once the IRS receives an offer, it will usually **stop any collection activity**. (In other words, if the Feds are about to garnish your paycheck, filing an OIC will put that on hold.)

In 1995, the IRS started applying "Collection Financial Standards" to its treatment of OICs; this removed much of the discretion that IRS Revenue Officers had to make deals. Instead, they had to follow charts which allowed set amounts for certain expenses and maximum allowances for others. (In particular, the Housing and Utility allowance formula made it difficult for homeowners in expensive areas to get OICs accepted.)

Still, an OIC is the most likely way to negotiate a tax debt; so, it's worth some attention.

Submitting an OIC is a formal process. You start by completing **IRS Form 656 (Offer in Compromise)** and submitting it to the IRS with a $150 application fee. In addition to Form 656, you need to submit a **Collection Information Statement, Form 433-A**.

If you are married and live in a community property state, the IRS may request that your Collection Information Statement include data on your spouse—even if the tax debt in question is in your name only.

After you've submitted the forms, the IRS will ask you for various financial documentation—pay stubs, bank records, vehicle registrations, etc. This can be an exhaustive, time-consuming process. But it's important to handle it completely. Revenue Officers will review your information closely.

In most cases, to make a successful OIC, you need establish that at least one of the following conditions exists:

- there is some doubt as to whether you owe the tax bill ("doubt as to liability");

- there is some doubt as to whether the IRS can collect the complete tax bill from you (the Feds calls this "doubt as to collectibility");

- due to exceptional circumstances, payment of your full tax bill would cause an "economic hardship" or would be "unfair" or "inequitable."

As with bankruptcy plans, loan modifications and other financial negotiations, it's important to remember when you're proposing an OIC that the collectors will focus more on **how much you can pay** than what you owe.

Most accepted OICs are lump sum settlements—in some cases, a few payments over a short period may be acceptable. But these payment schedules usually have to be completed within 90 days of an executed settlement agreement.

There are some downsides to making an OIC. If your offer is rejected, the disclosures you made about your assets give the IRS a lot of information that it can use to accelerate its collection efforts against you. So, if you're going to make an OIC, it's a good idea to make it work the first time.

> There is no legal right to have a valid tax bill reduced by the IRS—it is entirely a matter of government discretion. That said, the IRS is supposed to give any properly submitted OIC "fair consideration."

A caveat: There are many so-called **"tax practitioner" firms** that promise to use the OIC process to settle tax debts for "pennies on the dollar" without first asking about your particular circumstances. These firms (dismissed as **"offer mills" in industry jargon**) have a high rejection rate.

Some tips for avoiding offer mills:

- don't do business with a firm that won't let you speak to the people who are on the Power of Attorney before you sign a contract;

- stay away from any firm whose Web site doesn't clearly give the names and bios of the licensed (Enrolled Agents, CPAs or attorneys) employees;

- ignore guarantees, promises and so-called "testimonials"—especially testimonials that only use partial names;

- ask direct questions about the qualifications of anyone with whom you speak on the telephone or exchange emails—these questions should include: are you an Enrolled Agent, CPA or attorney? Do you own this company? What is your business relationship to the attorney or professional who will be handing my account?

Keep in mind that there's no such license as "tax resolution specialist."

COLLECTION POTENTIAL

According to the IRS, the amount of an acceptable OIC should be equal to the "realizable value" of your assets plus the amount of money the IRS could take from your future income. Together, these two items are what the IRS calls a "reasonable collection potential." The first number is relatively easy to calculate; the second is a little more challenging— usually based on the maximum that could be garnished from your current income.

For example, if the current market value of your assets is $25,000 and most that the IRS could garnish from your income over the next few years $15,000, your minimum offer needs to be $40,000.

> To calculate your reasonable collection potential, you need start with a list of the assets you own.

For most people, the biggest asset is the equity in their home. The IRS discounts assets such as homes and vehicles by 20 percent and then reduces the value further by anything owed against it such as a mortgage or an auto loan.

If the fair market value of your home is $200,000 and the mortgage is $150,000, the equity for IRS purposes is only $10,000 ($200,000 minus 20 percent minus $150,000).

You must also count your vehicles (the same 20 percent discount applies), retirement funds and the average balance in bank accounts.

For retirement funds, there's a different discount: whatever it would cost in taxes to take cash out now. If you're under 59 1/2 years old and are in a combined federal-and-state tax bracket of 40 percent, the IRS discounts the value of your retirement funds by 50 percent. (You'd pay 40 percent in taxes and 10 percent in early withdrawal penalties to get that cash right now.)

> **On this basis, total the value of all your assets. If that value exceeds the amount of tax you owe, an OIC is going to be practically impossible.**

There's another element to calculating an acceptable OIC—the amount you can pay the IRS each month. So, you'll have to anticipate how much the IRS will conclude it can collect from you each month. There's a formula for doing this: Your

monthly household income minus "necessary expenses."

> What *you* think is a necessary expense may be different from what *the IRS* thinks is necessary. There are caps on what the IRS allows for housing and utilities, transportation and food, clothing, etc.

Once you've projected the IRS's monthly payment estimate, multiply that by 48 and add the liquid value of your assets. The result of this is the minimum amount you should make in an OIC.

(If that total is more than what you owe, you shouldn't make an OIC—you're better off just asking for a payment schedule.)

This "factor of 48" is a big deal. It multiplies monthly numbers significantly. If you make a $100 error in your monthly expenses, your OIC will change by nearly $5,000. That can make a considerable difference in the deal.

NEGOTIATING THE OIC

Once you've submitted your OIC application, IRS examiners will review your numbers. This can take a few weeks—sometime a couple of months. They could agree that your offer is acceptable, or they could come up with a different amount and kick it back. You might estimate your house is worth $200,000 and the IRS says it's worth $300,000.

You might have to negotiate what your future wages will be and/or the current value of your assets. This is where the "compromise" comes in.

By some estimates, half of all OICs are rejected—at least initially. In IRS jargon, most of these offers are rejected because they aren't "valid." That means they don't follow the Collection Financial Standards.

If your offer is too low, the IRS rejection letter will normally state what amount is acceptable. You are also entitled to a copy of the report that lists the factors that led to the rejection. The IRS doesn't usually include a copy of this report with a rejection letter; but you can ask, in writing, for a copy. With this report, you usually have a solid basis for making a second OIC (even if it comes in slightly below the "acceptable" amount mentioned in the first rejection letter).

You don't need to submit a new Form 656 if:

- you submit a new offer within a 30 days,

- your financial circumstances have not changed significantly, and

- your new offer is not radically different from the old one.

If all of this is so, just write a simple letter—referencing your case number and stating that you wish to change your offer by increasing the amount of

cash. (However, if you're going to submit a significantly different offer, you need to complete another Form 656.)

An important point: In the late 2000s, the IRS made some changes in the OIC process that made the process a little less convenient for taxpayers. Effective mid-2008, anyone submitting an OIC had to include **a nonrefundable partial payment of 20 percent of the amount offered** as a settlement.

So, if you owe $100,000 in back taxes and penalties and calculate your settlement offer at $20,000, you need to include a payment of $4,000 (plus the $150 filling fee) with your application.

> **The risk here is that the IRS rejects your offer and keeps the money. Now, you still owe $96,000—and have restart your OIC application from square one.**

This is also a big reason that the letter within a month of rejection is important. **You don't have to pay another 20 percent to submit that.** Your letter is, technically, an appeal of the existing OIC.

This letter should include some version of the following request:

> *I wish to appeal from the rejection of an offer in compromise submitted June 20, 2006, and rejected on January 7, 2007. I request a conference with an appeals officer.*

An appeal of a rejected OIC will not be considered unless all of the following are true:

- you furnished all data requested by the IRS during your initial application,

- you have filed all past tax returns,

- you're current on tax payments (including self-employed estimates and payroll installments) for the present year.

If you determine the offer amount required by calculating the **realizable value of your assets** and your **available future income**, and the result is well beyond your ability to pay, consider making an offer anyway. IRS staffers have some leeway to accept less money than is required under strict application of the rules.

One important negotiation tip: The IRS gives special consideration to OICs from people with physical or mental infirmities. In particular, it favors offers from people with bleak financial prospects due to advanced age—especially people over 60.

The IRS will also consider drug- or alcohol-related problems—as well as a family member's problem, if it has a detrimental financial effect on you.

The best way to bring these sorts of circumstance to the IRS's attention is through a letter attached to the Collection Information Statement (Form 433-A). It doesn't have to be formal—just a page explaining your situation will often do. Statements

from doctors and medical records indicating the conditions will help; and, if the medical data doesn't show directly how the condition affects your finances, explain the connection in your own words.

One last point: If the IRS accepts your offer and you will **make payments over two years or longer**, the Feds may file a Notice of Federal Tax Lien showing your tax debt. The lien will stay on your records until the OIC has been completely paid or the statute of limitations for collection has expired.

INSTALLMENT PAYMENT PLANS

If you can pay your debt over time, an **installment payment plan** may be the right solution. Setting up a monthly payment plan with the Internal Revenue Service is fairly easy. Either you or your tax professional can set up an installment agreement either over the phone, by filling out some paperwork (specifically, **IRS Form 9465**), or by using the Online Payment Agreement web application.

The most widely used method for paying an old IRS debt is the monthly installment agreement, or IA. If you owe $25,000 or less, you should be able to get **an installment payment plan for 60 months just by asking** for it. (And, by its own guidelines, the IRS must accept your installment agreement if you meet certain criteria: your total tax does not exceed $10,000 and the monthly payments will pay your tax debt in full within three years.)

If you owe more than $25,000, you will have to negotiate with the IRS to get an installment plan.

The main requirement: You must be current on this year's tax returns. If IRS computers show that you haven't filed all past due tax returns, you will not be eligible for an IA. Likewise, if you are self-employed, you must be current on your quarterly estimated tax payments for the current year. If you have employees, you must be current on payroll tax deposits and Form 941 filings to get an IA.

You will also pay onetime user fees to set up or reinstate an installment agreement. The fees are:

- $52 for direct debit installment agreements, where payments are deducted directly from your bank account in a day of each month that you select,

- $105 for new installment agreements without direct debit,

- $45 for restructuring or for reinstating a defaulted installment agreement.

The biggest negative to setting up an IA is that interest and penalties continue to accrue while you pay. Combined with penalties, the interest rate is often 8 to 10 percent per year.

> **However, installment agreements can be particularly useful if they are combined with other tax debt reduction strategies.**

A caveat: Most of these IAs require the taxpayer to admit that the tax is owed and waive certain ap-

peals rights. So, these agreements should be something you set up only after you've exhausted other more favorable tax-reduction processes.

PARTIAL PAYMENT

Requesting a partial payment installment agreement with the Internal Revenue Service can be easier and less time-consuming than requesting an Offer in Compromise.

> **This is a fairly new payment option. Congress authorized the partial payment installment agreement option in the American Jobs Creation Act of 2004. The IRS implemented the option in January 2005.**

In a **partial-payment installment agreement**, you make regular monthly payments to the IRS, but the payments do not pay off the tax debt in full. After the terms of the installment agreement are fulfilled, the remainder of the tax debts is forgiven.

To set up a partial payment installment agreement, you can take the following steps:

- contact the IRS or get out copies of your tax returns to verify the amount you owe. Make sure this amount includes taxes due, plus penalties and interest;

- fill out Form 9465;

- fill out Form 433-A, Collection Information Statement (this form is used for

both partial-payment installment agreements and OICs);

- attach three months of backup documentation for all income and expenses reported on Form 433-A;

- write a letter stating your request for a partial-payment installment agreement and the reasons for this request;

- submit your written request along with Form 9465 and Form 433-A to the IRS Revenue Officer handling your case, to the Automated Collection System unit, or to your nearest IRS Service Center.

You'll need to file any back taxes before requesting an installment agreement. Before the IRS can approve your partial payment installment, you need have filed all your tax returns, and be current on your income tax withholding or estimated tax payments.

The IRS will respond to your request in about 30 days. And, even if you're approved for this type of IA, the IRS reserves the right to reevaluate your finances (and, possibly, revise the amount of your monthly payment) every two years.

IRS STATUTES OF LIMITATION

The IRS has three years to audit your tax return or to assess any additional tax liabilities. This is measured from the day you actually filed your tax re-

turn. If you filed your taxes before the deadline, the time is measured from the April 15th deadline.

For example, you filed your 2006 tax return on February 15, 2007. The three-year time period for an audit begins ticking from April 16, 2007, (the filing deadline) and will stop ticking on April 16, 2010. On April 17, 2010, the IRS cannot audit your 2006 tax return—unless there is a suspicion of tax fraud.

The IRS has **10 years to collect outstanding tax liabilities**. This is measured from the day a tax liability has been "finalized."

A tax liability can be finalized in a number of ways. It could be a balance due on a tax return, an assessment from an audit or a proposed assessment that has become final.

If the IRS doesn't collect the full amount in the 10-year period, then the remaining balance on the account disappears forever. The statute of limitations on collecting the tax has expired.

TAXES AND BANKRUPTCY

Under all types of U.S bankruptcy protection, certain debts are "non-dischargeable"—which means the person filing still has to pay them in full. These non-dischargeable obligations include child support, attorney fees, up to a year of mortgage payments...and taxes owed.

There are a few…very few…exceptions to this rule. The most common of these uncommon exceptions: If your personal back taxes are at least three years old and you voluntarily filed income tax returns for those years (IRS assessments and SFRs usually don't qualify), those debts may be discharged under a Chapter 7 liquidation.

> While a Chapter 7 filing may not be right for you, an attorney may recommend that you file a Chapter 13 to slow IRS collection actions. (For some workout arrangements, the IRS actually *wants* the taxpayer to file bankruptcy first.) If you are considering filing bankruptcy and the IRS has assessed against you, consult an attorney before filing any returns.

What about payroll taxes?

There are two portions which make up a payroll tax return, the trust fund (the taxes withheld from and paid by the employer on behalf of employees) and the non-trust fund (the taxes paid directly by the employer). Only the non-trust fund portion can be discharged—and that is normally around one-third of the total payroll tax due for a given period.

But, even in the very rare situations where taxes are dischargeable, you can't just walk away. Exempt assets that the bankruptcy court allows you to keep are still subject to Federal Tax Liens if the IRS filed prior to the bankruptcy. In other words, the IRS can still come after you—even though the bankruptcy discharged the taxes due.

HANDLING FEDERAL TAX LIENS

You owe taxes and have other financial problems, so you decide to sell your home. You find a buyer and reach an agreement to sell the property. A few days before you're scheduled to close the sale, your realtor calls you and says the title company has found a tax lien against you for $25,000. That means IRS is going to take every penny you were supposed to get form the sale—and there's not enough to pay them in full. If you can't fix this right away, you're going to lose this buyer.

There is a way out of this mess. It's called a Certificate of Discharge of Property from Federal Tax Lien—section 6325(b) of the Internal Revenue Code. (For details on applying, see **Appendix Two.**)

With this certificate, the property is sold free and clear of the tax lien. You will still owe the taxes you owed prior to the sale—minus the amount the IRS receives from the sale. The buyer will own the home and the lien will not attach to the property. The hard part of getting this Certificate is that three's a significant amount of paperwork that must be put together—and there's no specific IRS form to fill out. You have to do it completely on your own.

> In most cases, you'll need some professional help (from a tax attorney) to apply for the Certificate successfully. And the attorney will usually need 30 to 45 days to make the application.

NEGOTIATING PENALTIES

The IRS charges penalties for a number of reasons, among the most common being for not filing a tax return, for filing late, and for not paying taxes on time. Under certain circumstances, it is possible to negotiate with the IRS to request reduction or elimination of a penalty.

The most effective applications for relief from tax penalties fall into four categories:

1) reasonable cause,

2) statutory exceptions,

3) administrative waivers, and

4) correction of a service error.

Reasonable cause is the area in which taxpayers and tax preparers may be able to find some room for flexibility in negotiating a settlement of penalties for late filing or underpayment of taxes.

The Internal Revenue Manual states that "reasonable cause is based on all the facts and circumstances in each situation." The Manual goes on to say that

> *relief is generally granted when the taxpayer exercises ordinary business care and prudence in determining their tax obligations but is unable to comply with those obligations.*

The IRS Manual includes some specific examples; but each case is evaluated based on its facts and circumstances—and **what is reasonable cause in one case may not be in another**. In some cases, the IRS will require evidence that you acted in good faith and that your failure to comply with the tax law was not due to willful neglect.

> **Good faith is your honest belief that what you did was correct, and that you had no knowledge of anything that required further inquiry. It also implies that you had no intention to defraud. Willful neglect is a conscious, intentional failure or reckless indifference.**

The "ordinary business care and prudence" standard includes making the necessary provisions to meet tax obligations when reasonably foreseeable events occur. The IRS will also consider what you did to **comply with your tax obligations within a reasonable period of time** after the facts and circumstances that caused you to be unable to comply ceased to exist.

Past history is important in determining whether a request for abatement of a penalty will be granted. The IRS will look back several years (at least two years, according to the Manual) to see if you have had late payments or other instances of noncompliance in the past. If you have previously been assessed a penalty, this may indicate to the IRS that you are not exercising ordinary business care.

The fact that you have never been penalized before will indicate to the IRS that you have always tried to comply, and this time may be an unusual event. But, even if it is the first time you have been charged a penalty, this alone is not sufficient cause to reduce the penalty.

> **The IRS will take your compliance history into account along with the other reasons you provided for the late payment, late filing, or other noncompliance.**

In January 2009, IRS Commissioner Doug Shulman said the Feds would **waive late penalties, negotiate new payment plans and postpone asset seizures** for delinquent taxpayers who were financially strapped but made good-faith efforts to settle their tax debts.

However, he cautioned, those seeking help would have to **demonstrate their inability to pay**. And people who failed to file tax returns—or simply ignored collection notices—would not be eligible.

10

BANKRUPTCY AS A CRAMDOWN TOOL

If you're still having money problems—after you've renegotiated your mortgage and car and credit cards—you may have to consider using bankruptcy as the final financial renegotiation tool.

In previous chapters, we have suggested using the prospect (some might say *threat*) of filing bankruptcy as a tool for gaining leverage in negotiations. In this chapter, we will assume it's no longer a negotiating tactic; you're really looking at filing bankruptcy to protect yourself.

> Some self-styled "experts" say that once you get to the point where your debts outweigh your assets, the situation is ready for bankruptcy protection. Not so. Bankruptcy is *not* the best solution to a short-term cash flow crunch.

How do you know when you need to file for bankruptcy protection? There's no simple answer to that

question. But the answer is determined, ultimately, by two factors:

1) the size and type of your financial obligations (usually—but not always—measured in debt), and

2) the size and reliability of your income (or, in business terms, cash flow).

Some people think that bankruptcy is triggered by the relationship between your assets and debts; but these people are mistaken. Bankruptcy is triggered (or avoided) by the ability of your income to meet the *obligations* generated by your debts. Income or debt—each, by itself—doesn't mean much; taken together, they're an important financial indicator.

> To a household with a steady income of $20,000 a month, a $5,000 mortgage and $50,000 in credit card balances aren't a problem. To a household with an erratic income of about $7,000 a month, those obligations would be disastrous.

Steady income is as a valuable thing that needs to be protected. This is why some people who get into financial trouble because they lose their jobs wait to file bankruptcy until they've found new jobs—and have income to protect.

Too many consumers feel that their debts are overwhelming and there is nothing they can do other than file a bankruptcy. These people believe the tales spun by collection agencies of impending

doom, especially about garnishment and seizure of property. Collection agents fail to mention that, in order for these actions to take place, the creditor must first go to court. So, due to lack of information, many people turn prematurely to bankruptcy.

Bankruptcy should not be used until after all options are exhausted.

DEBT SETTLEMENT PROGRAMS

Before digging into the details of bankruptcy, let's discuss some immediate alternatives—starting out with debt settlement programs. These programs aren't a great alternative; but they can work if your money troubles are related primarily to credit cards.

A debt settlement—sometimes called "debt negotiation"—program is a cramdown of non-secured consumer debt to an amount (usually somewhere between 40 and 60 percent of face value) agreed upon by you and your creditor and paid off over a period of six to 24 months.

In most cases, you'll hire a third-party organization or individual to represent you in the negotiations with your creditor; in many cases, that third party will try to consolidate all of you non-secured consumer debt into a single account. And that third party will often use the threat of bankruptcy—*your* bankruptcy—to convince the lenders that a partial settlement over a reasonable period is better than nothing from a bankruptcy court.

Non-secured creditors (often, this means credit card companies) agree to debt reduction arrangements when they feel a settlement is in their best interest.

> **In most situations, lenders come to this conclusion because the person requesting the debt negotiation appears to be a legitimate candidate for bankruptcy. Knowing that in most bankruptcy cases they would receive nothing, they opt to take a discounted settlement rather than receive zero in a bankruptcy.**

Increasingly, debt settlement firms are specializing in consolidating and cramming down payday loans. "It's really the borrower's only chance to renegotiate paydays loans," says one California-based settlement professional, of his services:

> *Payday lenders take a hard line against renegotiating terms with borrowers. But they're more likely to talk to us—because they know the next stop is nothing.*

Debt settlement firms often promote the "single payment" or consolidation aspect of their services as a plus for clients. But that single payment isn't all good. There are **two major warnings** to heed if you're considering this kind of consolidation:

1) the single payment is often a little higher that the sum of the several cramdown settlement amounts; this is because the service will often add administrative fees to the total;

2) when you consolidate consumer debt, you are trusting the third-party to distribute your one payment as agreed among your creditors; some firms have screwed up that process.

In general, third-party debt settlement firms are something to avoid—for that second reason more than any other. Even if your single payment goes into an escrow or trust account, troubles can still follow. Through 2007 and 2008, numerous cases of settlement firms draining client funds out of "trust" accounts cropped up in the news.

Sometimes, lenders will accept cramdowns on non-secured debt—but **demand various conditions**, including that the borrower attend some approved debt counseling or financial education program.

If you encounter such demands, proceed carefully. Some debt settlement firms will claim that the classes are required (and will charge a fee for you to attend them) when they aren't.

If your creditors put conditions on your settlement, make sure they're not designed to squeeze more money from you.

SETTLEMENT VS. BANKRUPTCY

Debt settlement isn't a great solution to money problems. In most cases, it will show up as a black mark on your credit—usually as a charge off or some-

thing similar. This isn't as bad as a bankruptcy or repossession…and doesn't last as long…but it hurts your creditworthiness.

The benefits of negotiated debt settlements:

- With debt settlement, you can reduce your debt burden and pay off bills. You can negotiate with the creditors or collection agency and settle your debts for something you can afford to pay. You **don't need to file bankruptcy**—where there are chances (even if they're slight) of losing your home or car.

- Instead of paying multiple bills each month, you make **a single monthly payment** to the settlement company. As we've noted, this isn't alwats as good as it sounds—but some people like not having the stress of paying debts at different rates and dealing with several creditors at a time.

- You can **avoid unfair collection practices** and harassment by debt collectors if you negotiate a settlement.

- The settlement company may be able to **eliminate late payment fees**, etc. Over-the-limit fees on credit cards can also be minimized or eliminated.

- Creditors can file lawsuits, get judgments and garnish wages or place liens on property. Often, you can **avoid— or at least delay—such legal actions** if you're in a settlement program.

Should you pay a debt settlement company to help you make your deals? As with loan modifications and other financial renegotiations, this is a common practice. But, as in those other situations, it's not necessary to hire a service—you *can* negotiate a debt settlement yourself.

Here are the three most common reasons that people retain a debt settlement company:

1) They don't have the time to devote to this process. Negotiating settlements with creditors and collection agencies usually requires many well-planned phone calls and letters and proposals over a period of several months.

2) They don't have the skill level or knowledge. Each financial institution and collection agency has its own policies and procedures regarding settlement of outstanding debts and you need to know what these policies and procedures are to be successful.

3) They want a buffer between themselves and their creditors.

The key to using debt settlement programs effectively is understanding what kinds of debts you have—how much and what kind they are. It's usually tempting to think first about the total amount you owe. But it may be more practical to look first, instead about the kind of debt you have.

PRIORITIZING DEBTS

As we've noted before, the two main kinds of debt are secured and unsecured. A secured loan is backed, legally, by specific property that you own. If you fail to repay the loan as agreed, the lender has the right to take possession of the property and sell it to force repayment. The most common type of secured loan is a real estate mortgage; most car loans are secured. So-called "title loans"—connected to various valuables—are secured loans.

> **Secured loans are different than credit cards, certain personal credit lines and other forms of non-secured loans—which are not connected to any specific thing you own.**

One important step to take before moving forward with either a debt settlement program or a bankruptcy filing: make a list of all your debts, organized as either secured or non-secured obligations.

Why is the distinction so important? Because secured debts generally cannot be discharged in a bankruptcy proceeding. And they're rarely even modified in bankruptcy—though, in the late 2000s, that's been changing.

As we've noted, the types of debt that can't be discharged or modified by bankruptcy include:

- delinquent taxes,

- court judgments (including child sup-
 port payments), and

- government guaranteed student loans.

**Debt settlement firms often use the threat of bank-
ruptcy to force lenders to negotiate. As a result,
consumer-debt lenders have become savvy about
judging whether a person is likely to file.**

What kinds of people look like bankruptcy candi-
dates to most creditors?

- People who have shown an inability to
 pay their debts as evidenced by their
 failure to make payments for several
 months on their credit cards and other
 obligations.

- People who do not have assets to pro-
 tect such as equity in homes and cars.

- People whose current or future income
 would not allow them to reorganize
 their finances either through a Chapter
 13 or a plan outside of bankruptcy.

How do creditors find out this information? To start,
they will ask you or your settlement consultant.

Beyond that (and depending on how much you
owe), they will:

- review your payment history with
 them;

- take a loom at your current credit rating (you usually authorize non-secured creditors to inspect your credit report "when necessary" as part of the loan application);

- you may have to provide the creditor with additional information yourself (some creditors will never ask for this information; others will ask for it before any debt reduction negotiation begins);

If you have 10 credit card accounts and are current with nine, the tenth will make the assumption that you are capable of paying them as well. If you are delinquent with all 10, **each one will be more likely to conclude you really might file**.

DEBT CONSOLIDATION

Debt consolidation can provide some immediate relief from high-interest loans and debts. But be sure to run the numbers first. There isn't much sense in consolidating debts if your **underlying problem is an inability to pay anything**.

For instance, you have a car loan that runs for eight years. By computing your monthly payments and interest rates, you come up with $40,000—which is the total payments, including interest, you would have to make for the car loan. In addition to the car loan, you also pay $15,000 for items on a credit card if you pay the minimum for 30 years.

If you take a debt consolidation loan as a second mortgage, you can use the money to pay off other

debts. In most cases, this could significantly reduce your monthly payments and even stave off bankruptcy proceedings.

> **Debt consolidation is basically taking out one loan to pay off other debts. More often than not, it doesn't actually relieve you of any debt obligations.**

Borrowing money to pay off borrowed money isn't usually a good strategy. A debt consolidation loan, essentially, works that way: A lender provides a homeowner with a home-equity loan that will help "consolidate" his or her outstanding debts into one monthly payment. The homeowner can benefit from a lower overall interest rate and tax break—however, in the mid and late 2000s, many Americans' income situations were worsening as they borrowed and consolidated.

If you don't own a home with enough equity this may not be an option at all, or if you have less than perfect credit your rate for this type of loan may be similar to your credit card rates.

CREDIT COUNSELING?

As we noted previously, creditors and lenders may require you to get credit or financial counseling as a condition of any debt settlement. In some cases, the same connection flows the other way—consumer credit counseling (CCC) organizations may offer to help you negotiate debt settlement deals as part of your recovery from financial troubles.

The CCC industry includes many different types of organization and company. Some are designated as non-profits by the IRS—although, in the early 2000s, many of these firms lost that status because the IRS felt that they had "for profit" motives. These organizations combine your payments to one monthly payment, where you pay back all of the principal, some interest and some fees. Many CCC organizations **receive funding from creditors** as well as payment from their clients.

Many times these programs are drawn out over four to six years; and fewer than one in four consumers complete the programs.

In some cases, the payments reached as part of a CCC renegotiation are *higher* than the original credit card payments. And these programs—like debt settlement programs—can have a bad effect on your credit.

BANKRUPTCY STRATEGY

The purpose of bankruptcy isn't to give a debtor a "do over" on his or her finances.

Bankruptcy was originally designed to protect creditors—by giving them an orderly and reasonably predictable way to settle accounts with insolvent borrowers. It was meant to give them a mechanism for getting clear answers about a debtor's financial situation.

A bankruptcy plan is supposed to establish a realistic value for the debts a troubled borrower has accumulated—and a plausible schedule for repaying at least part of them.

The problem comes when you have so much non-secured debt that those lenders sue you, win, get court judgments formalizing (effectively securing) their claims...and then garnish your wages, put liens on your assets or otherwise endanger your ability to keep current in payments on your secured debt.

> **In this situation, you might use a bankruptcy filing to get rid of (or reduce) the non-secured debts, so that you can concentrate on bringing the secured debts current.**

You should concentrate on bringing those secured debts current if one or both of two factors are true:

- your house suits the needs of your family and you plan to stay in it for more than five years;

- you have equity in the house that you need to protect.

On the other hand, if you don't plan to live in the house for much longer and it doesn't have any positive equity value, it may make sense to walk away from the debt.

A few months of unemployment or **a few angry calls from bill collectors** aren't sufficient reason to

file bankruptcy. You should consider bankruptcy as a last resort to protect assets you own (read: your house) or to bring systemic debt into line with your new, lower income.

You should only consider filing is there is a **direct legal threat**: someone has sued you or is about to—and is likely to win a judgment against you.

Another rule of thumb: If you're past due on three or more accounts because of a permanent decrease in your income—and the creditors on those accounts won't renegotiate the debts—then bankruptcy may be a necessary option.

Before you decide to file, here are the things that you need to know:

- What are your alternatives to bankruptcy?
- Which chapter of the Bankruptcy Code should you file under?
- What debts will be discharged in bankruptcy?

THE MECHANICS OF BANKRUPTCY

The U.S. federal bankruptcy code is divided into several dozen chapters. Some of these chapters— near the middle of outline—describe the various categories of legal proceeding that individuals, com-

panies and government entities can use to discharge or renegotiate debts. The most common of these chapters are:

- Chapter 7 liquidation
- Chapter 11 restructuring
- Chapter 13 restructuring

Most people thinking about bankruptcy are thinking, whether they realize it or not, about a **Chapter 13 court-supervised reorganization of debts**. In most cases, this legal proceeding allows a person to renegotiate existing debts while keeping possession of certain property—usually meaning his house.

In a Chapter 13 reorganization, your creditors agree to a payment plan that lasts three to five years. When the plan is done, the unpaid balances of your *un*secured debts are discharged. The secured debts (your mortgage, tax debts, court judgments and child support) have to be paid off, or at least brought current, during the plan's timeframe.

Some important elements of a bankruptcy filing:

- Petition the Court: At the beginning of the process, you have the change to explain your situation to the judge. This means providing lists of your assets and debts—and a suggestion, if you have one, for how to settle the debts.

- The Court Appoints a Trustee. After the judge has reviewed your petition, he or she appoints a trustee (in most cases, a lawyer whose work or reputation is

known to the judge) to oversee the day-to-day implementation of your reorganization. The trustee, standing in for the Court, has broad powers over your financial circumstances.

- Creditors' Committee and/or Section 341 Hearing. Soon after the trustee is named, you creditors have a chance to respond to your plan. If your debts are large enough, your creditors may form a committee that meets with the trustee to review plans and approve specific actions; more often, in personal bankruptcy cases, instead of a committee there's a Section 341 hearing—where creditors have a chance to confront you and review your workout plan. Most creditors prefer simply to "reaffirm" their claims.

In most cases, creditors don't show up to Section 341 hearings in personal bankruptcy cases. But don't *assume* they won't.

- The Plan Is Approved. After the trustee has consulted with your creditors, he or she meets with the judge and approves your reorganization plan. In most situations, the judge will follow whatever suggestions the trustee makes.

- The Plan Is Executed. For 38 to 60 months, you have to live according to the plan approved by your judge.

While you may control your day-today banking and money transactions, the trustee has the right to review all of your business—and take over your accounts if you aren't following the plan.

- Debts Discharged. At the end of the plan period, the trustee reports to the judge on how effectively you have followed the plan. In most cases, the judge will discharge any remaining balances on unsecured debts and may modify (but not discharge) any balances left on secured debts.

Secured debts "go live" again once you emerge from the bankruptcy plan. This means that the creditors can resume aggressive collections tactics.

However, most reorganization plans will require you to be current on secured debt payments before you emerge from the plan. So, you should not be in default or foreclosure at that point.

If there is no equity in a secured asset—or the debtor is in an "upside down" position—the lender can choose to refuse reaffirmation and just take possession of the secured property. **This is most common in case of leased or financed automobiles**; the finance companies will usually repossess the vehicle rather than participating in a workout plan.

If you file a Chapter 13 and are behind on taxes, the taxes usually must be paid in full during the

plan (the IRS will object if they aren't properly addressed in the plan). If the taxes aren't paid in full, the IRS or other authorities can resume aggressive collection tactics as soon as the plan is over.

CHAPTERS 11 AND 7

A Chapter 11 bankruptcy filing is like a Chapter 13—except that it doesn't usually involve the three- to five-year payment period. It proceeds more quickly to the discharge of debts.

While individuals can file Chapter 11 bankruptcy, they usually don't. That proceeding is **more often used by corporations** and businesses.

A Chapter 7 bankruptcy involves the **forced liquidation** of the debtor's assets. While it is possible for an individual to file Chapter 7 bankruptcy, it is rare. (Before the bankruptcy "reforms" passed by Congress in the early 2000s, people who didn't own a home but had a lot of unsecured debt could file for Chapter 7 liquidation. The reforms made that more difficult.)

> In most cases, individuals have to file Chapter 13, which requires you to pay back a portion of your debt under the supervision of the court.

These days, Chapter 7's almost always involve companies.

Forced liquidation may make financial sense for troubled companies…but it's usually what individuals are trying to *avoid* by filing bankruptcy.

Most creditors don't distinguish between a Chapter 7 and Chapter 13 bankruptcy—down the road, your credit will take a beating in either case. For 10 years or more.

How badly does a bankruptcy filing harm your credit? There's no one answer to that—it depends on how bad your credit was before you filed. But consider these points:

- bankruptcy creates a public record; anyone who's interested—noisy neighbors, angry exes, career rivals—will be able to see the details of your financial life;

- a bankruptcy filing stays on your credit report for up to 10 years, depending which state you live in;

- although bankruptcy is a federal process, individual state courts have discretion about managing records; in some states, bankruptcy records are permanent;

- increasingly, employers ask job applicants the question "Have you ever filed bankruptcy?"

- in most cases, a bankruptcy will hurt your credit score more than a foreclo-

sure, short sale, deed-in-lieu, repossession or other secured-asset problem;

- people often believe they cannot qualify for a car loan or credit card after filing bankruptcy. However, many lenders *will* extend credit after a filing. Why? Because you can't file again for another seven years;

- court and lawyer fees accompany the process of filing for bankruptcy; these fees "go to the front of the line" in payment plans and can be very costly.

In some situations, secured lenders may *want* you to file bankruptcy—to maximize the payments you can make on your mortgage, by getting rid of your credit card debts. This is something that credit card companies have tried to make more difficult by means of the various bankruptcy "reform" proposals passed into law during the 2000s.

TRICKY BANKRUPTCY MANEUVERS

The "Second Mortgage Cramdown" or "Chapter 13 Lien Strip" is a bankruptcy tactic that can help distressed home owners de-lever their homes.

In 2008, proposed "mortgage cramdown" legislation would allow Chapter 13 judges to reduce mortgage balances to "fair market" or current market values. The Chapter 13 Lien Strip accomplishes a similar result using existing law.

Specifically, the existing Bankruptcy code section 1322 states:

The plan may…modify the rights of holders of secured claims, other than a claim secured only by a security interest in real property that is the debtor's principal residence, or of holders of unsecured claims, or leave unaffected the rights of holders of any class of claims.

What's not obvious about this language is that a loan is not "secured" by your personal residence if there is no value or equity in your home that would go to the lender if the home was sold.

That means a loan—usually a second mortgage or home equity line of credit—can be converted to unsecured and corresponding the lien "stripped" from the house by "modifying the rights of holders of secured claims."

This turns it into unsecured debt, like credit card debt, which can be discharged.

For example: You bought a house for $100,000 with 100 percent financing using an 80/20 loan. Your first mortgage is $80,000 and your second mortgage is $20,000. Two years later, the market is down more than 20 percent and your house is now only worth $75,000. If the house was sold, the first mortgage would take all of the sale proceeds and the second mortgage would get nothing. In this case the second mortgage is "wholly unsecured" and the second clause of Section 1322(b) does not apply—so you modify the rights of the second mortgage holder and turn it into unsecured debt.

What happens to the unsecured—"stripped"—second mortgage? It gets paid in your Chapter 13 plan but only after your other secured debts are paid. Secured debts are the first mortgage, your property taxes, and your car payments.

Because a Chapter 13 plan lasts only three to five years, most of that unsecured debt doesn't get paid. At the end of five years, most unsecured debts (not student loans, back income taxes, or family support payments) are discharged. You don't have to repay them.

> **At the end of five years, you are left with just your just mortgage payment on your house. Your cars and your back property taxes are paid off, your student loans and back income taxes are paid down, but your second mortgage and your credit card debt is discharged.**

A major downside: You must make every plan payment for three to five years. If you fail, everything goes back to the way it was. You owe all that debt, and the second mortgage is no longer stripped. So you need to make a budget that will *work*—not just look good to the Bankruptcy Court.

CARS AND BANKRUPTCY

An auto loan or lease is a secured loan. That means that, in bankruptcy, even if you miss just one payment, your car can be repossessed without even giving you advance notice.

How to prevent this?

1) Contact the lender and try to renegotiate the terms of your loan to allow you make lower monthly payments, make interest-only payments, or extend the length of the loan term. Even if a lender were to agree to these compromises, that lender would want to know how you were going to make up the difference (possibly in a lump sum at the end of the loan or lease term).

2) If the lender refuses to alter the terms of your loan and repossesses the car, you'll be notified where and when the car is to be sold at auction. One option you have is to show up and "redeem" the car (buy it back), by paying, in one lump sum, the balance remaining on the lease or loan, late fees, and repossession costs. Again, you can try to negotiate the price.

3) File a Chapter 13 bankruptcy. If you file before your car has been sold by the creditor (most will try to do this), the creditor *has* to return the vehicle to you. You can then arrange, as part of the bankruptcy, to "buy back" the car over a 36-60 month period.

In a bankruptcy, you can redeem the asset (usually cars…but this also applies to other things that have been financed) at **current value**. It has to be done in cash. There are companies that will do loans for this—but the interest rates are high.

> Some bankruptcy attorneys claim that their clients have had increasing success negotiating with automobile finance companies to modify terms of car loans after the clients filed bankruptcy.

The declining value of used cars in a weak economy has made car lenders more flexible. Some lenders are willing to modify interest rates, payment amounts, and even reduce loan balances to entice troubled borrowers to reaffirm the car debt.

A recession means lenders are less interested in repossessing used cars—and more likely to renegotiate with debtors who are behind on car payments at time of filing.

Still, if you're sure you're filing bankruptcy, the car finance company will usually repossess the car or ask you to surrender it "voluntarily" at or near the Section 341 creditors hearing.

Some car lenders will step in sooner. For example: Ford Motor Credit is known to repossess vehicles, absent an approved reaffirmation agreement, even if the bankruptcy debtor is current on his car payments. It can do this because its standard financing contracts are nullified if the borrower files.

FILING AS NEGOTIATING TOOL

Still, you can **use the prospect of bankruptcy as a negotiating tool**. If you are preparing to file bankruptcy and are behind on car payments you might

try calling your car lender to see if you can convince them to modify your car loan. If the lender refuses to discuss modification, call again after you file bankruptcy.

Some bankruptcy filers are better off giving up their present car even if their lender might improve rates or terms. The simplest solution is to file bankruptcy and buy an inexpensive used car for cash or with low payments.

> **Even if you pay a higher interest rate, the higher rate of a modest car loan is usually more affordable than a modified car loan on an expensive car with negative equity.**

If you do decide to file bankruptcy be sure to have an attorney explain all the details of the bankruptcy laws and its applications before you proceed.

If your goal is to prevent foreclosure, then the bankruptcy judges should be allowed to bifurcate the debt. Banks could easily learn the idiosyncrasies of the judges because in most areas the address of the debtor would let you know the judge you'd be in front of.

In early 2009, bankruptcy cramdown legislation was a terrible idea. Leaving aside the idea that this new law would make a mockery of contract law, what congressmen failed to see was that this would (were it to be implemented widely) blow a new hole in bank balance sheets.

Many of the mortgages that could be modified through bankruptcy court are part of mortgage-backed securities. Due to a quirk in the documentation, these bankruptcy losses are treated differently than foreclosure losses. Bankruptcy losses are absorbed by riskier slices of the securities—which helps protect the AAA rated bonds. These first loss pieces are the first lines of defense against losses on loans held in mortgage backed securities.

If a bank (or other entity—like an insurance company or other institution) holds a bond that it believes is AAA and now it is taking losses, the bond will be downgraded immediately. After the downgrade the bank (or other institution) has to write down or sell the asset and has less capital. Now, it must raise capital in the open market or get another bailout.

> Foreclosures are a problem which needs to be dealt with, but modifying bankruptcy law is not the way to deal with it. The unintended consequences could be quite dramatic and unforeseen by legislators.

For precisely those reasons, the solution is not about creating special treatment for these loans—it's about *removing* the special treatment.

And again, I really think this is more about protecting the credit card debt, because this change might get more people to file Chapter 13, and they'd probably come often totally wipe out their credit card debt.

In the spring of 2009, Michigan congressman John Conyers, Jr. introduced a new version of a pending bankruptcy expansion proposal. His proposal would allow bankruptcy judges to reduce payments and principal for homeowners with troubled mortgages, waive payment penalties, stop or modify the interest rates on adjustable-rate mortgages and to extend the length of mortgages to 40 years.

Some said that allowing judges to renegotiate the terms of troubled mortgages would open the flood gates of bankruptcy courts; however, some banks supported the bill. Their theory: If bankruptcy judges had the power to renegotiate terms, banks would be more willing to take a proactive approach in renegotiating directly with the homeowner before he or she took the first step toward filing.

THINK HARD BEFORE YOUR FILE

Filing for bankruptcy protection can be devastating both economically and emotionally. While there's less public stigma attached to the act of filing for bankruptcy protection than there was 50 years ago, it can still hurt your reputation...and hinder your confidence in making other important financial decisions. Now and later.

But it is, simply, **the ultimate form of cramdown**.

If you have no choices left and *must* file, think of bankruptcy as an extended renegotiation. **Try to keep as much** of your money (though you prob-

ably don't have much) and assets (you may have more of these) as you can.

Don't flinch. Don't hesitate. And good luck.

APPENDIX ONE

LETTERS TO USE IN RENEGOTIATING DEBTS

As part of a loan modification process, most lenders will require you to submit a **hardship letter**. This is a written explanation of the circumstances that caused you to need some change in your existing contract. It should serve less as a financial document—those need to be submitted, too—than as a "backgrounder" that gives narrative context to the financial data you provide.

Keep in mind that the hardship letter will be read by an employee of your lender (or loan servicing company) who's likely to be busy and backlogged with many loan mod applications to review. So, keep it short—usually one or two pages should do.

Here are some common hardships that lenders look for in support a loan modification (or other debt renegotiation):

- illness,
- unemployment,
- divorce or marital separation,

- failed business,

- job relocation,

- incarceration,

- military duty,

- reduced income,

- medical crisis,

- damage to property (natural or man-made disasters).

While most lenders will look for one of these standard reasons—and the first three are most common—you hardship letter needs to be specific to your circumstances. If you have young children, mention that; if you've tried to sell your house without success, mention that.

A final note: Most lenders want to see some indication that you are moving away from the hardship that has caused you to ask for the modification. So, indicate what you have done, are doing or will do to improve your situation. Even a plan to improve things is better than nothing.

Here are some sample hardship letters. The first is designed for a job-loss or divorce scenario:

Your Name
Your Address
Your Lender
Your loan #

Ladies and Gentlemen,

I am writing this letter to explain the circumstances that have caused me to become delinquent on my mortgage—and to request assistance in modifying my existing loan. My main financial goal is to keep my family's home. We appreciate any help you can give us in doing that.

Situations like ours are the result of many things; but the main reason that has caused us to be late is [DESCRIBE HARDSHIP SIMPLY AND QUICKLY. INCLUDE DATES. AIM FOR UNDER 20 WORDS. SEE LIST ABOVE FOR COMMON REASONS.]. In dealing with this problem, we've fallen behind on our credit accounts. It is our intention to pay what we owe—but, right now, we've exhausted all of our income and cash reserves so we are turning to you for help.

We have made a plan for getting out of our current situation and begun executing that. I expect that our household cashflow will be able to cover our expenses in [INSERT NUMBER OF MONTHS HERE... OR STATE THAT EVEN AN IMPROVED CASH FLOW WILL NOT BE ENOUGH TO COVER CURRENT DEBT SERVICE]. In order to get to that better place, we need a modification of certain parts of our loan. Specifically, we would to [LOWER OUR DELINQUENT AMOUNT OWED OR RESTRUCTURE OUR MONTHLY PAY-

MENT] so we can keep our home while we bring our household budget into line.

I understand there are several government programs that are designed to help homeowners in circumstances like ours. We would appreciate any guidance that you can give us in identifying and applying for those programs.

We hope that you will consider working with us on this account. We believe that, with some help, we can get our financial situation to a sustainable place—and keep our account with you and active and productive one.

Sincerely,

Your Signature Date

Co-Borrower's Signature Date

The following hardship letter is designed for scenarios in which an adjustable rate mortgage (ARM) has reset to an unsustainably high payment.

Your Name
Your Address
Your Lender
Your loan #
Re: Mortgage modification program

Due to the recent adjustment to the mortgage I currently have with your company, I am finding it very difficult to afford the new payment. I have a 3 year fixed rate

which is now adjustable and is schedule to adjust again in [NEXT ADJUST DATE].

Considering my current income, there will be no way I can afford the increased payments as of [DATE, PREFERABLY LESS THAN A YEAR AWAY]. I hope there is some way to renegotiate the terms of my current mortgage to avoid default and help stop foreclosure on my home.

Is it possible to have my current adjustable rate mortgage converted to a fixed rate?

If this is not possible can the next rate change be postponed to a future date to allow me to hopefully refinance. Any other solutions you could provide would be greatly appreciated.

I have had no problem making my payments for [AMOUNT OF TIME INTO LOAN] and do not want that to change. I knew when is signed this loan that an adjustment was possible; I thought that I could refinance when this time case—but that turned out not to be true due to the downturn of the housing industry.

The main problem is that my property is now worth about [PERCENTAGE DROP] less than what I paid for it; this is preventing me from being able to refinance.

I know that there are some government programs that can help in my situation. I was researching on the Internet and came across the Fannie Mae Announcement #06-18 (Oct. 4th 2006) regarding the servicing of

Conventional Mortgage Modifications. I believe this addresses the situation I currently find myself in along with many other homeowners. Attached are recent pay stubs showing my current income.

Thanks you for your time and consideration.

Sincerely,

Your Signature Date

Co-Borrower's Signature Date

If you've already had a loan workout, modification, forbearance or other adjustment, your prospects for getting a loan mod are not so good. But some homeowners have managed to negotiate multiple modification. Here is a letter for that situation:

Your Name
Your Address
Your Lender
Your loan #

I have a [DESCRIBE] loan that was transferred to [YOUR BANK AND DATE ORIGINATED OR TRANSFERRED]. We fell behind when [DESCRIBE PAST HARDSHIP]. I accepted a forbearance deal and kept our house. We got back on track and have not had a late payment since [DATE]. I am self-employed in [INDUSTRY OR OTHER DESCRIPTION OF EMPLOYMENT] and my wife has a steady income. But business has slowed down dra-

matically in the past few months and, as a result, we are [TIME OR NUMBER OF PAYMENTS] late in our mortgage. Also our rate will be adjusting in [DATE], making our payments [AMOUNT] higher.

I am currently looking for permanent employment [DESCRIBE OTHER PLANS]. But, in the meantime, I see challenges ahead on meeting our mortgage payments as they are. What we need is to convert our mortgage to a fixed-rate loan and to eliminate the late payment fees that have raised out amount due. This will help us stay on track for the long term.

I contacted your customer service department and [REP'S NAME AND DATE OF CALL] suggested that I send in documentation to apply for a loan modification. Those documents [DESCRIBE THEM] are attached with this letter.

Our home meets my family's needs well. I've already fought hard to keep this house—and I'll continue to do everything I can so that my family can stay in our home. Please let me know if any of the government programs available will work for my situation. Thank you.

Sincerely,

Your Signature Date

Co-Borrower's Signature Date

POINTS TO REMEMBER

When you're writing your hardship letter, keep these points in mind:

- Keep a written history of names, locations and employee numbers of everyone you with whom you've spoken. In your letter, refer to these contacts.

- Your **debt-to-income ratio needs to be high**. It needs to show that, if the lender *doesn't* modify your loan, you're likely to default.

- You shouldn't have a lot of equity in your home. If you do, the lender will suggest you sell.

- You need to show your lender that, if it *does* modify the loan, **you *can* afford the revised deal**.

And a final note: Customer service reps may "prequalify" you over the phone for a loan mod; but that's not worth much. The important thing is that you submit your hardship letter and supporting documents—and **confirm they have been received**.

APPENDIX TWO

DEALING WITH IRS
TAX LIENS

As we mention in Chapter 9: Taxes, it is possible to negotiate the sale of a piece of real estate that has one—or several—federal tax liens attached. This isn't easy, but it can work to your interest (getting out of a mortgage you can't afford) *and* the IRS's (getting at least some cash paid against your debt).

The thing you're looking for from the IRS is a **Certificate of Discharge of Property From Federal Tax Lien**. To apply, you need to be in contract or escrow for the sale of the encumbered property. There is no standard application form for this Certificate. You need to make your request in the form of a letter and submit it (with all relevant escrow documents) to:

IRS, Attn: Technical Services Group Manager

Care of the IRS office that filed the lien

(Use IRS Publication 4235, Technical Services Group Addresses, to determine where to mail your request.)

The letter should begin:

> Hello. My name is {NAME} and I reside at {ADDRESS THAT APPEARS ON THE TAX LIENS}. I am applying under section 6325(b) of the Internal Revenue Code for a certificate of discharge.

Next, you need to describe the details of the liens, the property affected and the transaction that's pending. Specifically:

1. Give a description, including the location of the property for which you are requesting the Certificate of Discharge. If real property is involved, submit a legible copy of the title or deed to the property. If the Certificate is requested under section 6325(b)(1), give a description of all the taxpayer's remaining property subject to the lien.

2. Show how and when the taxpayer has been or will be divested of all rights, title and interest in and to the property for which a Certificate of Discharge is requested.

3. Attach a copy of each notice of federal tax lien, or furnish the following information as it appears on each filed Notice of Federal Tax Lien:

 a. The location of the Internal Revenue Office that filed the lien

 b. The name and address of the taxpayer against whom the notice was filed

 c. The serial number shown on the lien

 d. The taxpayer social security number or employer identification number shown on the lien

 e. The date and place the notice was filed

4. Instead of the above, you may substitute a preliminary title report listing the required information.

5. List or attach a copy of the liens, mortgages, or other encumbrances against the property, which you believe have priority over the Federal tax lien. For each encumbrance show:

 a. The name and address of the lien holder

 b. A description of the encumbrance

 c. The date of the agreement to the encumbrance

 d. The date and place of the recording (if any)

 e. The original principal amount and the interest rate

 f. The amount due as of the date of the application, if known (show costs and accrued interest separately)

 g. Your family relationship, if any, to the taxpayer and to the holders of any other encumbrances against the property

6. Instead of a through f above, you may substitute a preliminary title report listing the required information.

7. Itemize all proposed or actual costs, commissions and expenses of any transfer or sale associated with the property, or submit an estimated closing statement, also known as a Form HUD-1.

8. Furnish information to establish the value of the property. If the Certificate is requested under section 6325(b)(1), furnish an estimate of the fair market value of the property that will remain subject to the lien. In addition,

 a. If private sale—Submit written appraisals by two impartial persons qualified to appraise the property, with a brief statement of each appraiser's qualification.

 b. If public sale (auction) already held —Give the date and place the sale was held, and the amount for which the property was sold.

 c. If public sale (auction) to be held— Give the proposed date and place of the sale, and include a statement that the United States will be paid in the proper priority from the proceeds of the sale.

9. Give any other information that might, in your opinion, have bearing upon the application, such as pending judicial actions.

10. The Technical Services Group Manager may request that you furnish additional information.

11. If you are submitting the application under the provisions of section 6325(b)(3), dealing with the substitution of proceeds of sale, attach a copy of the proposed agreement containing the following:

 a. The name and address of the proposed escrow agent

 b. The caption, type of account, name and address of depository for the account

 c. The condition under which the escrowed funds are to be held

 d. The conditions under which payment will be made from escrow, including the limitation for negotiated settlement of claims against the fund

 e. The estimated costs of the escrow

 f. The name and address of any other party you and the Technical Services Group Manager determine to be a party to the escrow agreement

 g. Your signature, and those of the escrow agent, the Technical Services Group Manager and any other party to the escrow agreement

 h. Any other specific information the Technical Services Group Manager requests.

12. As discussed below under "Additional Information," making an application and deposit (or providing a bond) under section 6325(b)(4) provides a judicial remedy not available for an application and payment made under section 6325(b)(2). Therefore, unless the right to make a deposit under section 6325(b)(4) is waived in writing, an application made by a third party claiming ownership of the property will be treated as one made under section 6325(b)(4), and any payment made will be treated like a deposit under section 6325(b)(4).

If you are an owner of the property (other than the taxpayer) and you wish to submit an application under section 6325(b)(2), you must waive the rights that would be available if the application were made under section 6325(b)(4). Add the following language to the application immediately prior to the declaration described in paragraph 15, below: "I understand that an application and payment made under section 6325(b)(2) does not provide the judicial remedy available under section 7426(a)(4). In making such an application/payment, I waive the option to have the payment treated as a deposit under section 6325(b)(4) and the right to request a return of funds and to bring an action under section 7426(a)(4)."

13. Give the address and telephone number where you may be reached.

14. Give the name, address and telephone number of your attorney, if any.

15. If you have made an application under section 6324(b)(4) and disagree with the Service's determination of the value of the government's interest, provide us with specific reasons why you disagree with it's determination.

16. Make the following declaration over your signature and title: "Under penalties of perjury, I declare that I have examined this application, including any accompanying schedules, exhibits, affidavits, and statements, and to the best of my knowledge and belief it is true, correct, and complete."

ADDITIONAL INFORMATION

The Technical Services Group Manager has the authority to issue a certificate of discharge of a lien that is filed on any part of a taxpayer's property subject to the lien. The following sections and provisions of the Internal Revenue Code apply:

Section 6325(b)(1) – A specific property may be discharged if the taxpayer's property remaining subject to the lien has a Fair Market Value (FMV) which is double the sum of: a) the amount of the liability secured by such liens, and b) all other liens which have priority over the federal tax liens. $(FMV = (a+b)x2)$

Section 6325(b)(2)(A) – A specific property may be discharged if there is paid, in partial satisfaction of the liability secured by the lien, an amount determined to be not less than the value of the interest of the United States in the property to be discharged. In the case of entireties property sold by the taxpayer or taxpayer's

spouse, the United States must be paid one-half of the proceeds in partial satisfaction of the liability secured by the tax lien.

NOTE: Because making an application and deposit (or providing a bond) under section 6325(b)(4) provides a judicial remedy not available for an application and payment made under section 6325(b)(2), owners (other than the taxpayer) wishing to apply for a certificate of discharge under this provision must waive, in writing, their rights to make a deposit allowed under Section 6325(b)(4) and to file suit for return of the deposit or accepted bond allowed under section 7426(a)(4). Unless the waiver has been provided in writing, the Service will treat an application made by an owner of the property (other than the taxpayer) as an application made under section 6325(b)(4), with all funds treated as a deposit.

Other than the judicial review available under the deposit/bond procedures under sections 6325(b)(4) and 7426(a)(4), there is no remedy available to the third party for the return of payment (or portion thereof). An administrative request for refund and a refund suit in district court is not available.

Section 6325(b)(2)(B) – A specific property may be discharged if it is determined that the interest of the United States in the property to be discharged has no value.

Section 6325(b)(3) – A specific property may be discharged if the property subject to the lien is sold, and, under an agreement with the Internal Revenue Service, the proceeds from the sale are to be held as a fund subject to the liens and claims of the United States in the same manner and with the same priority as the liens and claims on the discharged property.

Section 6325(b)(4) – A discharge may be issued to third parties if a deposit is made or an acceptable bond is furnished in an amount equal to the value of the government's interest in the property. In the case of former entireties property, a deposit of one-half the value of the property or a bond equal to one-half of the value of the property will be determined to be the government's interest. An owner of property (other than the taxpayer) who makes a deposit or furnishes a bond and obtains a discharge under section 6325(b)(4) has, under section 7426(a)(4), 120 days after the discharge to file an action in federal district court challenging the Service's determination of the government's lien interest.

This is the exclusive remedy available to the third party for the return of the deposit or accepted bond or a portion thereof. An

administrative request for refund and a refund suit in district court is not available. See section 7426(a)(4).

1. No payment is required for the issuance of a certificate under section 6325(b)(1) or 6325(b)(2)(B) of the Internal Revenue Code. Payment is required for certificates issued under section 6325(b)(2)(A). Do not send the payment with your application. The Technical Services Group Manager will notify you after determining the amount due.

2. The Technical Services Group Manager will have your application investigated to determine whether to issue the certificate and will let you know the outcome.

3. A certificate of discharge under section 6325(b)(2)(A) will be issued upon receipt of the amount determined to be the interest of the United States in the property under the Federal tax lien. In the case of entireties property sold by the taxpayer or taxpayer's spouse, the Service's interest will be one-half the value of the property. Make payments in cash, or by certified, cashier's, or treasurer's check. Checks must be drawn on any bank or trust company incorporated under the laws of the United States, or of any state, or possession of the United States. Payment can also be made by United States postal, bank, express or telegraph money order. (If you pay by uncertified personal check, issuance of the certificate of discharge will be delayed until the bank honors the check.)

4. If application is made under sections 6325(b)(2)(A) or 6325(b)(2)(B) and is for the sale of a principal residence, the taxpayer may be eligible for a relocation expense allowance based on an inability to pay, and subject to limitations. This allowance will be taken from sale proceeds and will not reduce the tax liability. To apply for the allowance, complete and submit Form 12451, Request for Relocation Expense Allowance, with the application for discharge.

5. If application is made under provisions of section 6325(b)(2)(A), or 6325(b)(2)(B) because a mortgage foreclosure is contemplated, there will be a determination of the amount required for discharge or a determination that the Federal tax lien interest in the property is valueless.

Within 30 days from the date of the application, you will receive a written conditional commitment for a certificate of discharge. When the foreclosure proceeding has been concluded, a certificate of discharge will be issued in accordance with the terms of

the commitment letter. Also, see Publication 487, How to Prepare Application Requesting the United States to Release Its Right to Redeem Property Secured by a Federal Tax Lien.

6. If application is made under the provisions of section 6325(b)(3), the Technical Services Group Manager has the authority to approve the escrow agent you select. Any reasonable expenses incurred in connection with the sale of the property, the holding of the fund, or the distribution of the fund shall be paid by you or from the proceeds of the sale before satisfaction of any claims or liens. Submit a copy of the proposed escrow agreement as part of the application.

7. A certificate of discharge under section 6325(b)(4) will be issued when an amount equal to the United States' interest in the property is received. In the case of former entireties property, our interest will be one-half the value of the property. Payment of the interest of the United States in the property may be made in the form of cash, other certified funds, or the posting of a bond acceptable to the Secretary.

8. Submit Form 12180, Third Party Authorization. Completing this document gives us the authority to contact individuals or companies, if necessary, when determining if the discharge is appropriate.

9. Provide the name, address and telephone number of your attorney or representative as well as the closing attorney or Settlement Company.

10. If your application is denied, you have appeal rights. Form 9423, Collection Appeal Request, and Publication 1660, Collection Appeal Rights, will be issued, along with an explanation of why your application was denied.

So, half of all recent American college graduates
have school-related debt. And one in 10 of those is
behind on his payments.

Renegotiating student loans is a growing business.
In this chapter, we'll consider the details.

To get started, there are two types of student loan:

- **Subsidized**: Loans for which a borrower
 is not responsible for the interest while
 in an in-school, grace or deferment sta-
 tus. These loans tend to have lower in-
 terest rates—often in the range of 3 to
 8 percent per year. Specific types of sub-
 sidized loan include Direct Subsidized,
 Direct Subsidized Consolidation Loans,
 Federal Subsidized Stafford Loans and
 Federal Subsidized Consolidation
 Loans; they include loans from the De-
 partment of Education and FFELP loans
 (which are guaranteed by state or re-
 gional government agencies). FFELP
 loans are issued by companies such as
 Sallie Mae, Citibank, Wells Fargo and
 other banks.

- **Unsubsidized**: Loans for which a bor-
 rower is responsible for paying the in-
 terest regardless of the loan status. In-
 terest on unsubsidized loans accrues
 from the date of disbursement and con-
 tinues throughout the life of the loan—
 and it tends to be high, often in the
 range of 10 to 25 percent. Specific types
 of unsubsidized loan include Direct
 Unsubsidized Loans, Direct PLUS

6

STUDENT LOANS

A 2008 survey by the National Center for Education Statistics indicated that just about 50 percent of college graduates had student loan debt, with an average balance of over $10,000. According to the College Board, total borrowing for university-level education in the United States was $85 billion during the 2007-2008 school year—up from $41 billion a decade earlier.

The percentage of private (that is, not government-guaranteed) student loans grew from 7 to 23 percent during the same period. Private student loans cause more problems than most young borrowers realize. They come with higher interest rates than government-backed loans; and they contribute to increasing overall levels of student loan debt.

SLM Corp. (commonly known as "Sallie Mae"), the largest private student loan company in the U.S., reported a delinquency rate of 9.4 percent in September 2008—up from 8.5 percent a year earlier.

- if the car is new, driving it off the lot depreciates it significantly. Any car considered used is of less value—even if is *barely* used;

- people usually don't place high enough down payments on their vehicles to prevent an upside down car loan;

- many people are attracted by low monthly payments that will keep the loan upside down longer because payments aren't covering much more than interest in the early years of the loan.

Also, some people trade in a car that they still owe money on, and this debt is transferred to the new car loan, which can mean the new loan is automatically upside down and may remain so for a while.

There are a few ways to help prevent an upside car loan. The best? **Don't buy new cars.**

Never borrow money against an asset that depreciates. And, since new cars *always* depreciate, auto finance companies are in the business of avoiding cramdowns.

The best strategy for dealing with an expensive car loan is suffer through it—and stop leasing or buying new cars. By buying a car that is a year or two old, you can **avoid the brutal depreciation** in value that occurs when a new car leaves the lot.

design financing packages to be like this precisely so that you have little incentive to get out.

> **Most new car buyers *expect* that they will be driving an upside down car for the first few years of a lease or loan. If the person intends to keep the car for a long while, this should not be important.**

If you owe more than the car is worth and you want to lower your monthly payment, you'll usually have to come up with cash to get a lower interest rate.

There's a greater prospect of negotiating the repayment amount and terms. But **you can't refi an upside down loan**. Most refi lenders will only lend to 100 percent of the existing loan. (Some will got to 110 percent—but these are usually "bad credit" deals that include mandatory credit insurance, etc.)

As we've noted before, the only way—usually—to lower a car payment is to get a longer term on the remaining balance. You wind up paying longer, at a higher rate, in order to get a lower monthly note. And **you end up upside down again or for a longer time**. This is something you should do only under the most extreme situations.

The upside down car loan is actually a fairly common thing in auto financing. Estimates differ, but reports on American car loans suggest that about 30 to 40 percent of loans for new cars are upside down at any given time. There are a number of reasons for this: